Just add
WATERCOLOR

Just add
WATERCOLOR

INSPIRATION & PAINTING TECHNIQUES FROM CONTEMPORARY ARTISTS

HELEN BIRCH

WATSON
GUPTILL
PUBLICATIONS

BERKELEY

Contents

The paintings

Flipping through this book

On pages 6 through 9, you'll find a visual index that will help you dip in and out of this book. Use it to find specific watercolor paintings quickly and easily. If you're trying to find an image you've already seen in the book, or are looking for a specific style, color, or background, use this index to take you straight to the right page. Page numbers appear on the thumbnail for each painting. Please note, however: where there is more than one painting included in an entry, only one will feature in the visual index.

Each artist is credited alongside their work and the name of the painting appears in the accompanying text. At the back of the book you will also find an alphabetical list of all the artists and, where relevant, a link to their blog or website so you can look up more of their work.

Borzoi by Itsuko Suzuki

55 61 67 69 75 77 83 89 91

57 63 71 79 85 93

59 65 73 81 87 95

What is watercolor?

Water + watercolor paint + paper + paintbrush
= watercolor painting

This simple formula indicates what you will need in order to start painting with watercolors and gives an idea of just how simple watercolor painting can be. There are lots of established rules about the "traditional" approaches that are considered the foundations of good watercolor painting. While it is useful to pay heed to some of these rules, they shouldn't make you hesitant.

Watercolor is familiar to us. If you've ever painted on paper, you've probably already used a water-based paint. The brush, loaded with water and pigment, easily transfers color to the paper surface. It is a playful medium and welcomes experimentation. Fluidity, drips, runs, and color blooms are all characteristic of watercolor paintings.

The aim of this book is to show a range of works of varying styles and levels of complexity, using watercolor, gouache,

and acrylic paints, as well as ink. Some of the works are fairly immediate in execution while others were produced over a much longer period. The choices of brush, paper, and pigment are important factors in the production of the paintings and illustrations. Accompanying each work is a short exploration of the artist's approach and the techniques used, so you can try some of the ideas out too.

Watercolor work is as technique intensive as you want it to be. It can be immediate and portable and produce traditional or contemporary outcomes that are delicate or robust, richly colorful or subtle. If you are a beginner, take things slowly and enjoy each stage of discovery. If you're more advanced, try out something new.

This page: *Spritz* by Yellena James
Following page: *Roots* by Junyi Wu

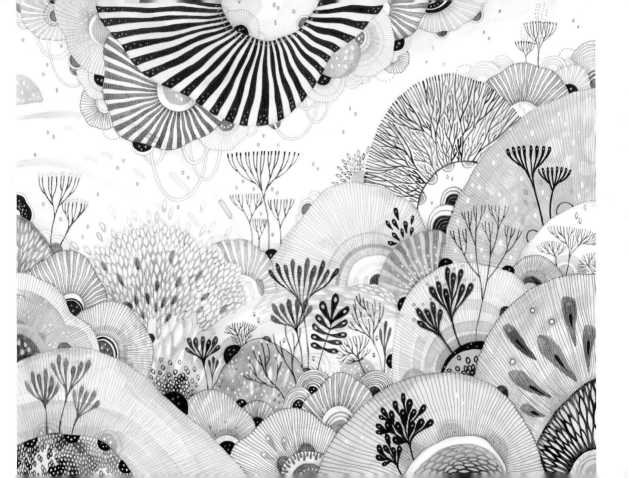

Working in monochrome

Eleonora Marton

Three Bathers was produced using one color, blue, and one technique, wet on wet—a process that involves layering paint of varying tones. This process can be demanding and the lack of pencil guidelines suggests that the artist spent quite a lot of time preparing and practicing the brushstrokes before beginning the piece. The artist occasionally switched to wet on dry, as is evident with the central bather. She is less diffuse than the others, which suggests the paper was allowed to dry before she was painted, resulting in more sharply defined facial features.

A watercolor paper with a minimum weight of 200lb. (per ream), or 300gsm, is preferable for wet-on-wet painting. The paper must be able to withstand the application of water without curling, buckling, or distorting too much. Here, hot-pressed paper was chosen because of its smooth and even surface.

Tip It is useful to have a cool blue (i.e., one with a green bias) in a basic watercolor palette. The cool blue used in this example is Prussian blue, although there are other options, including phthalo blue, cerulean blue, and winsor blue.

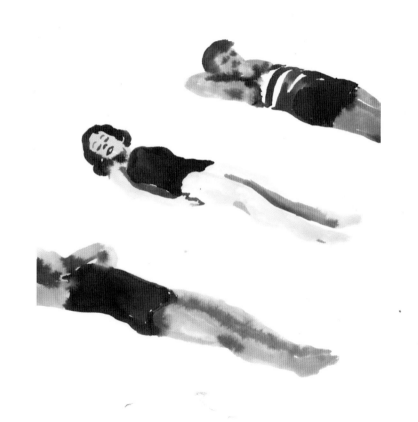

Daytime and nighttime

Kaye Blegvad

At first look, these urban scenes possess a distinctly sketchy feel, thanks largely to the looseness of the brushwork. This, however, belies the many stages and processes that were involved in making the paintings. For the nocturne, *Reykjavik by Night* (left), a black wash was applied and left to dry before the city residences were rendered wet on dry for sharper definition. The painting consists largely of three tones of black, with the yellow of the windows offering points of striking contrast. The textured look provided by the paper adds an urban "grittiness" and also recalls the "noise" you might see in a photo taken in low light.

By painting the same scene in the daytime (*Reykjavik by Day*), the artist offers a fascinating point of comparison with the nocturne. You can see more clearly the tonal values of the colors and the degree to which daytime shadows lose definition. Putting two images together like this is reminiscent of the children's game "spot the difference." You can't help but compare and contrast the two images, finding their similarities as well as their differences.

Tip Washes can be applied to a paper not ordinarily recommended for such wet paint use. If a brush is worked over the surface a little too much, it can cause pilling to occur, whereby paper "bits" form on the surface. This is actually the paper breaking up. It can be good for creating texture.

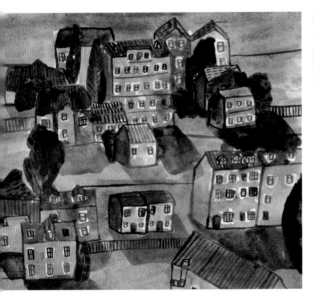 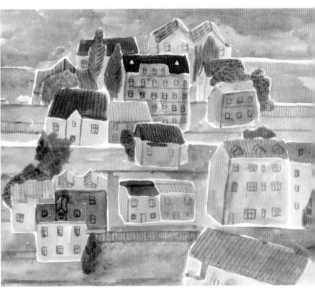

17

Bold and unusual colors

Leah Goren

The crowd scene in this painting, *Girl Crowd*, is dominated as much by its unusual and striking color scheme as by the figures that populate it. It is unusual to choose a pink background for an illustration, but then it's unusual, too, to choose red as the dominant color.

Red is classified as an advancing color because it tends to create a sense of proximity. In this example, the women in the crowd appear as a rather two-dimensional wall of individuals, even though they get smaller the further back they are. The cropped edges of the composition concentrate the image and encourage you to scrutinize it more closely. Much of the piece was painted dry on dry using a high-quality (and more expensive) sable brush.

Tip Think carefully about how you're going to use red before you start your piece of work. It can be a striking device in creating your image, but it's also a very dominating color.

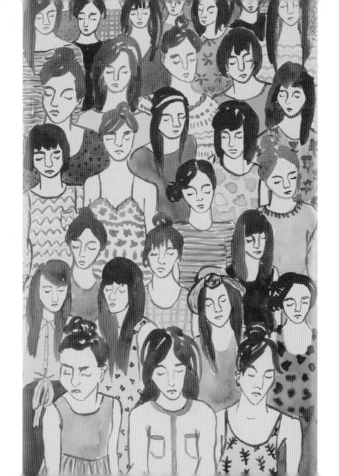

Everyday inspiration

Loui Jover

When collecting ideas for your next painting project, get inspiration from the things you have around you. Everyday items are easy to overlook but they offer a near-limitless range of possible subjects.

This painting, *All Stars,* is a celebration of something familiar—the artist's own footwear. Because these sneakers are a bit of a design classic you can see how successful his rendering is. You can also see the experimental way in which he has worked the image up; it is perhaps a little unusual to see sneakers displayed at such a large size.

The artist has found a novel surface to work on: 20 pages cut from old books and glued together. Through experimentation he has learned that the absorbency of those old papers suits the ink-wash technique. The natural browning of the pages adds interest to the image.

Tip If you try something similar, use water-based glue to attach your book pages. Plastic-based glues such as PVA are waterproof when dry and will effectively "resist" the painting medium.

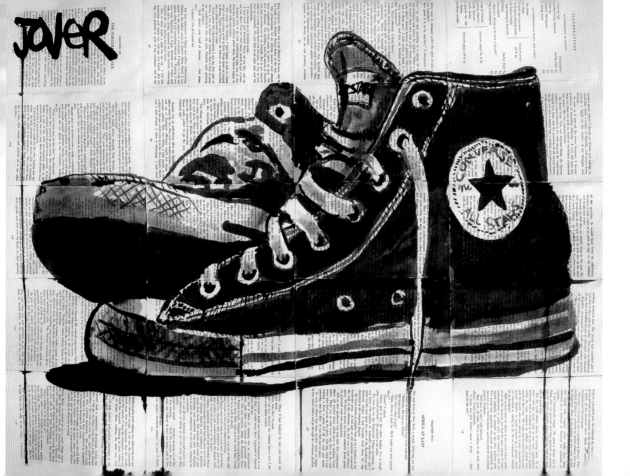

High-key colors

Luka Va

In this piece, *Their Ancestors Were Wolves*, a domesticated dog looks at us from behind an orange mask. The whites of the dog's eyes, set within this darker tone, help to focus our attention.

This painting is a good example of an opaque watercolor. The orange wolf, painted in what is called a high-key color, remains bright, showing up clearly on the brown recycled paper. A transparent watercolor would not be as effective on this paper. A characteristic of opaque colors is that they dry with a matte surface, much like gouache paint does. Pencil, which is used for the dog, works well on top of this matte surface.

Every watercolor has specific characteristics. In order to work effectively with them, it is important to know the characteristics of each pigment. As you experiment with your paints you'll find out what these are. Here the artist has exploited that knowledge to great effect.

Tip Using white on a colored background can be very effective. The "chalkiness" of white gouache paints and white pencils ensures they stand out against darker tones. This makes them particularly useful for adding highlights to a work.

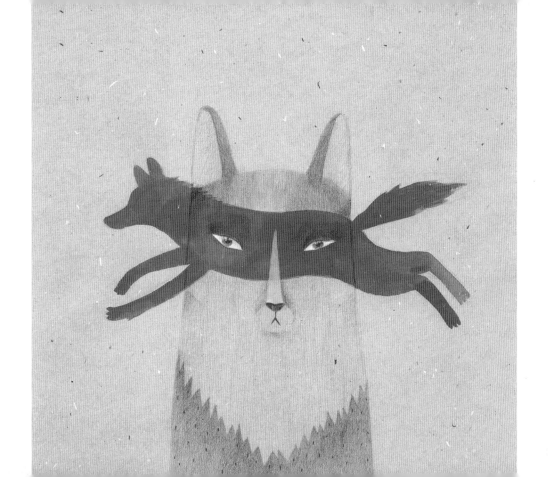

Glazed landscape

Madara Lukjanoviča

Mountain landscapes are a familiar subject for watercolor paintings and offer artists a good opportunity to hone their skills. In this example, a sequence of flat and layered (sometimes referred to as "glazed") washes combine to create a stylized look.

This painting, *Mountains*, achieves aerial perspective and depth through subtle tonal development across seven layers. The progressively darker tones were achieved by lessening the amount of water added to the pigment. Each layer was left to dry completely before the next one was applied, thereby reducing the risk that the previous layer would lift and ruin the gradated effect. Using soft brushes will also help with this.

When attempting a similar project, it is a good idea to select a color you have used before and whose characteristics you are familiar with. If you want to work with a paint you haven't used before, test it first on a scrap of paper. Remember that watercolors always dry lighter.

Tip Check if a wash is ready for the next application by touching it gently with the back of your hand. If it is cool to the touch it is still too damp. Use a hairdryer on a low setting if you want to speed up drying times.

Paper highlights

Holly Exley

This simple still life of blueberries in a bowl employs the traditional watercolor technique of overlaying translucent color washes on white paper, with areas of unpainted paper used to indicate highlights. As more washes were overlaid the colors and tones deepened.

Each blueberry in this painting, *Blueberry Bowl*, represents a mini study of layered tones. Prussian blue watercolor paint was carefully applied, wet on dry, one layer at a time. Notice how the dark berries have white spaces. The ceramic bowl, painted in paler and warmer tones with some wet-on-wet technique on its outside curve, reflects the blue-purple of the fruit on the inside. The palest blue is also used to define the bowl's right edge; this is a clever and subtle use of warm and cool colors. The bowl also uses white spaces for its highlights. No black was used to make this image. Payne's gray, a dark blue-gray color, was used instead because it is much less intense than black, allowing even the shadow and the spoon to maintain a clean, light, and brightly translucent quality.

Tip Areas of an object facing a light source will be lighter, while those away from that source will be darker. Sharp contrasts of light and dark imply bright light whereas more closely matched tones suggest a more diffused light.

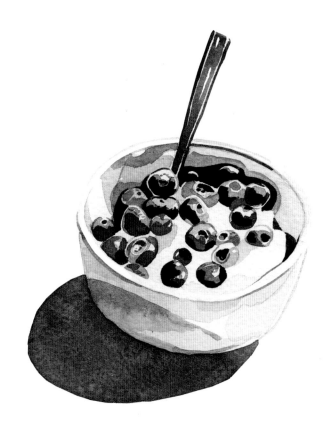

Reinventing traditional techniques

Loui Jover

This image is an exercise in experimenting with technique and style. It represents the artist's own take on the traditions of Sumi-e ink-wash—painting with black ink. The subject matter, scale, and the use of a collage of found paper as a background represent an interestingly different approach.

Paper type is important when painting with Sumi-e ink. It should be moderately absorbent as this will allow the ink to stay on the loaded brush long enough to produce the lingering, almost calligraphic marks of Sumi-e. Overly absorbent paper will draw ink from the brush too quickly. Note how, in this example, the variable absorbency of the pages affects the way the ink lies on the page.

The Sumi-e technique allows for a rich tonal range, from stark black to lighter grays—something this artist has used to good effect. The image is called *Birds*, after the feathered appearance of the long black eyelashes of the subject.

Tip You might want to use a specialist paintbrush to complete an ink wash painting. These brushes are similar to those used for calligraphy, with hairs tapered to a fine point. They are readily available from good art suppliers.

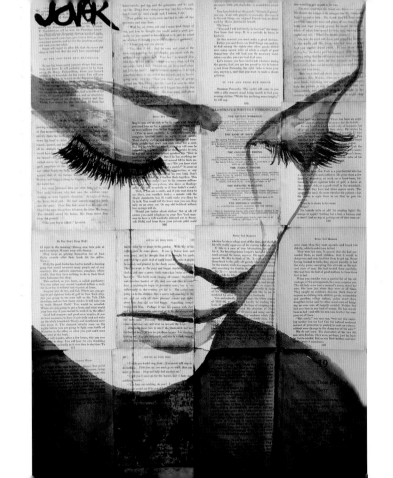

29

Using familiar symbolism

Marina Molares

The laurel or bay leaf has long been used as a symbolic and decorative detail in architecture, furniture, and textiles, and this familiarity presents a challenge to artists who want to use it in their work. Unless they want to produce a pastiche of past styles, they must find new and imaginative ways of using it. The artist's combination of techniques in this image achieves just that by combining classical watercolor with contemporary marker pen.

This painting, *Laureate*, feels natural: the plant form flows and seems to grow into and around the space. The artist elegantly arranges the curving forms so that they intertwine and overlap. Permanent black marker pen was used to outline the design and a green watercolor was then added over it, providing a counterpoint of looseness to the flat surface and neat line work, particularly as the color occasionally strays outside the lines.

Tip Clean, graphic lines like this are not easily achieved through freehand drawing. Using graphite paper is a good way to give yourself guidelines you can carefully ink over before adding paint color to your image. Try tracing the outline of your subject (directly from a photograph perhaps). Place it over your watercolor paper, with a sheet of graphite paper in between (coated side downward). Now go over over the top drawing; as you do so, the graphite will transfer it to the watercolor paper.

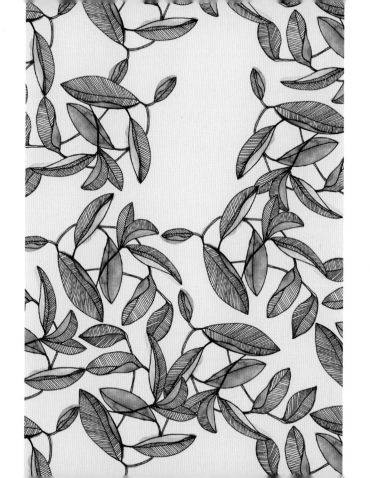

31

Negative space

Monica Ramos

Paintings communicate with us on various levels. We learn as much about an artist's technique from what is not shown as from what is presented to us on the paper. This painting, *Warm Water*, is particularly interesting because of its treatment of negative space—the blank space between what has been painted. As the artist paints this space, swimmers appear in the gaps she leaves and the light tone of the unpainted paper becomes their skin.

In paintings where multiple objects are created from the negative space, it is best to use masking fluid as a resist. In this example, the masking fluid was carefully removed after the wash had dried and a darker tone of turquoise was used to create the outlines of the people beneath the pool's surface. Finally, colored pencil was used to pick out costume details and some facial features.

Tip You can apply masking fluid with a brush, but make sure it's an old one. Alternatively use a color shaper—a silicone-tipped tool ideal for applying or spreading glues and adhesives, as nothing sticks to the tip. (It's also good for applying acrylic paint.)

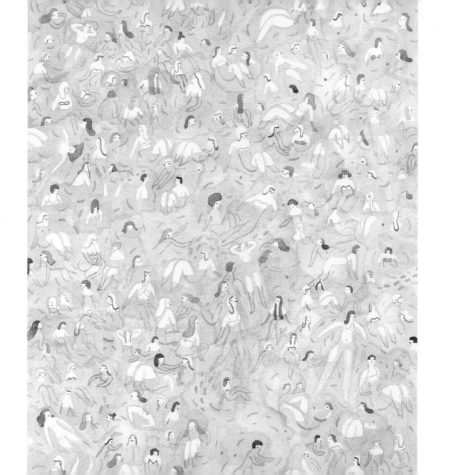

Evening scenes

Elizabeth O'Reilly

In this nighttime scene, called *Night Lights on 3rd St.*, the different violet tones perfectly capture a moment in early evening, as daylight fades and the lights come on, and reflections begin dancing on the water's surface.

The composition here applies the rule of thirds. A base wash of saturated violet, representing the dark water, was applied to the lower two-thirds of a sheet of watercolor paper. A paler wash of the same color, applied to the upper third, accounts for the sky. Despite their simplicity, the semi-transparent washes really do capture a sense of fading light.

The industrial landscape visible at the water's edge was created using sections of paper, painted in various watercolor tints, that were cut to size and glued into position. The collaged details use the interplay of complementary colors effectively. One small detail of red provides a pinpoint of warmth.

Tip Granulation, the mottled effect produced when pigment particles settle on the paper, is apparent in this painting. Not all pigments will cause granulation; it is, however, possible to imitate the effect by adding a granulation medium, which is available at art supply stores..

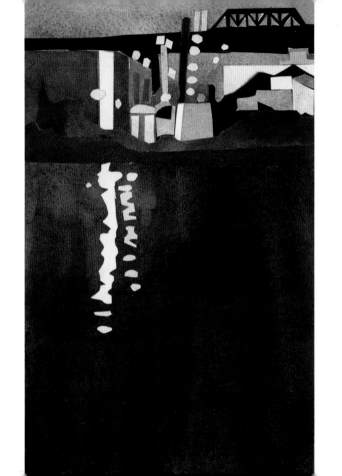

Using secondary colors

Nadja Gabriela Plein

The artist's initial idea for this painting, *Snow Forest 32*, came from a Swiss forest in wintertime. To maximize the visual impact of the painting's colors, high-quality watercolor paper was selected and the paint was applied wet on dry—a technique that proved to be highly effective. The colors seize our attention, followed closely by the stripe formation of the tree trunks. Purple dominates the scene, and its richness is balanced by the other two secondary colors: green and orange. The touch of yellow offsets the purple further (the two colors are opposites on the color wheel and so have an enriching effect on one another).

The composition of the painting has been carefully thought through. The strong vertical arrangement begins at the bottom left of the page with the bases of the tree trunks following a curve upward. The sense of depth created by the painting is emphasized by the artist's appreciation of perspective: the trees' silhouetted forms are narrower the further toward the background they are. Using a tint of the purple as an infill between the trees also adds to this sense of distance—the colors fade the further they are from us.

Tip Selecting the correct brush size is often key to the success of a painting. A "round" watercolor brush in two different sizes might be useful here—a larger one for the trunks, a smaller one for the branches and pale mauve dappled areas in the canopy.

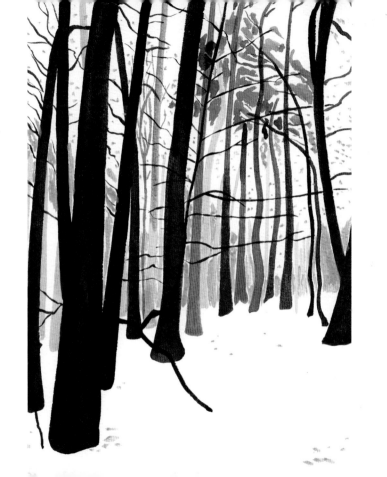

Preparatory sketches

Simona Dimitri

These watercolor paintings, collectively called *The Flowers' Tree*, display a confidence and lightness of touch. Although stylized, the pieces have been developed from direct observation of the natural world, something the artist considers very important. Before beginning these paintings, the artist made several preparatory sketches, drawing on her own visual memory as well as direct observation of objects.

The trees in these paintings have fluid, graceful forms. Their trunks have been painted with a wide brush dipped in clean water. After a broad stroke was applied, the surface tension of the water allowed another color to be added without spilling or bleeding. Working like this means that larger areas of color can contain greater subtlety.

The artist places a lot of importance on color and she uses it to good effect in the leaves and flowers of the trees. The palette of each tree is harmonious and subtle, yet feels very bright and light. The combination of turquoise blue and red provides the zing factor.

Tip Accurate lines and dashes are difficult to do with a brush. Instead, try using a dip pen or fill a reservoir fountain pen with your chosen color of ink.

Keeping things spontaneous

Sophie Lécuyer

This is a very understated and informal still life. Its subject, a collection of cacti in mismatched containers, is an ordinary scene in many homes. The challenge to the artist is to find an interesting way to paint it. Rather than adopting a radically different approach, the key to this kind of still life painting lies in capturing the immediacy and ordinariness of the items. Of all the paints, watercolor is perfect for this.

There is something spontaneous about this piece, *Tiny Cactus*. There are no preparatory sketches— instead the pot forms were laid down with a few quick brushstrokes, wet on wet. Several greens make up the cacti forms with an added touch of black for the darker tones. The warm earth tones of the terracotta pot were also used as an underwash for the plant on the right. The only other color is a purple mat or shadow at the base of one pot. Unusually, China ink has been added to the watercolor to create the black contrasts and give more of an impression of depth. The spikes and thorns have been dragged from the wet media—possibly with the "wrong" end of the brush.

Tip Pulling, dragging, and blowing wet paint are all good techniques for shifting color from a wet area of paint. In this painting, the technique defines the cactus spines; consider using it to paint fur, grass, or flower stamens too.

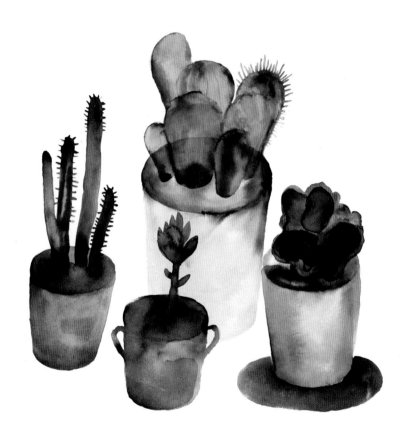

41

Create a composite image

Talya Baldwin

This piece, called *Olive Tree with Crows*, is a composite image. The olive tree and four separately rendered birds have been brought together to form a strikingly artificial whole. The maroon olive tree has been rendered loosely; the brushstrokes are fluid and the leaf shapes are simplified loops. Look at the trunk: the color is applied thickly at the base and thins as the brushstroke moves upward. That dilution of color is a mark of this medium, and so too is its layering: a first layer of leaves was completed, and then a more saturated version of the color was added on top. The only difference was in the amount of water used in loading the color to the brush.

The birds were painted in a much more technical style and at a larger scale before being resized digitally and added to the tree. Using photographs as a reference will help you achieve a similar depth of detail, and of course it helps to be familiar with the subject—something that comes with repeated practice.

> **Tip** Although this painting has been rendered digitally, making the combination of its elements seamless, don't be afraid to do the same using scissors, or an X-Acto knife, and glue. There are several examples of very successful "manual" cut and paste paintings in this book.

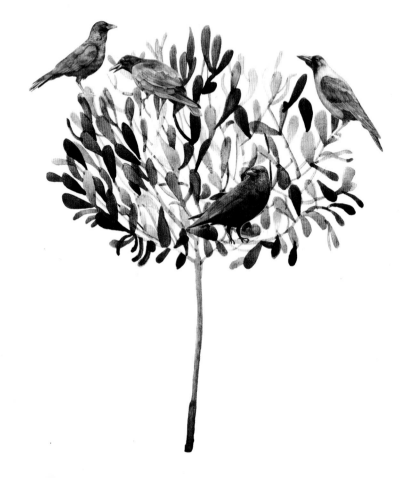

Phthalo green

Cate Edwards

Phthalo green is used to good effect in this painting, called *4 Bowls on Green*. It is a versatile paint that offers a full tonal range from light to dark through the addition of water. It doesn't overpower the painting, instead uniting the components of this still life.

The four bowls and their decorated surfaces were marked out with preparatory guidelines, and the painting stays inside those guidelines. The undisguised lines are an integral part of the image. Ultimately, this is an observational piece that takes delight in color. The painting brings the surface designs of the bowls alive, with the external pattern becoming an animated object contained within them.

Tip Visit paint manufacturers' websites—they often provide detailed information about their paints that can be useful and interesting. Paint characteristics, ingredients, staining, granulation, and lightfastness can vary enormously.

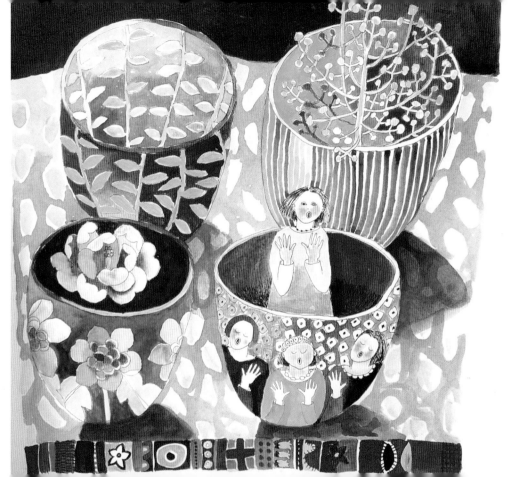

Including patterns in a still life

Holly Exley

The mismatched cups in this painting, *Teacups*, stacked into two columns, make for an unusually precarious arrangement in a still life. Rather than choosing to make the six cups identical, the artist has opted for a variety of styles and arranged them in an engaging way. She has used a number of colors (rose pink, Prussian blue, yellow ocher, and permanent mauve) several times on different items. For example, look at the gilt patterns and edgings common to all of the cups.

The beauty of watercolor, whether you use paint from a pan or a tube, is that they can be "reactivated" very easily. Unlike acrylic or oil, the addition of water revitalizes them and makes them usable once more. The palette on which you mix your colors should be white (so that you can judge them accurately) and made from plastic or ceramic. It could even be a saucer that didn't make it into this still life because it bore no pattern!

Tip Remember, the names of colors are not shared by manufacturers, so be sure to check paint charts online, or ask at your local art supplies store for a printed brochure of available colors.

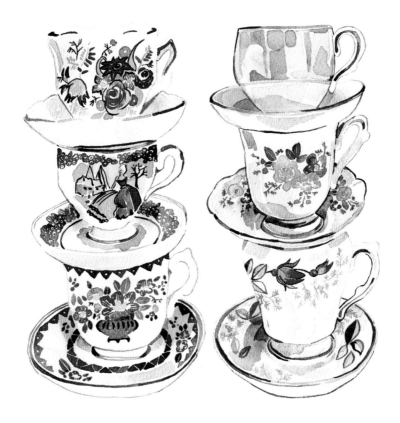

Using tone to create depth

Elizabeth Baddeley

The artist uses her understanding of aerial perspective to give this cityscape, called *Rainy City*, spatial depth. Her representation of the scene from her studio window is successful because she is able to create an impression of 3D space on a 2D surface by gradually fading the tones from foreground through to background. The palest tones appear toward the top of the painting. The lift-out technique is useful for creating these tones: a brush to dampen the surrounding area and some paper towels to lift away the watercolor are all you need to do this. The artist has also used the technique effectively to create the impression of smoke billowing from some of the buildings. In contrast, the darkest tones are situated in the lower portion of the image, with black used only in the foreground area.

Linear details were added with gel roller pens. Ruled dashes of white depict the slanting rain and the roof ladders in the foreground. The window frames are rendered with dissipating tones of gray. In an otherwise monochrome painting the yellow-filled windows add an intimacy to the image; perhaps others are looking out on to this rainy day too.

Tip Black is available as a watercolor but consider mixing your own using equal amounts of all three primary colors—red, yellow, and blue. Depending on the balance of the primary colors you choose, your blacks can be soft, medium strength, or strong and bold.

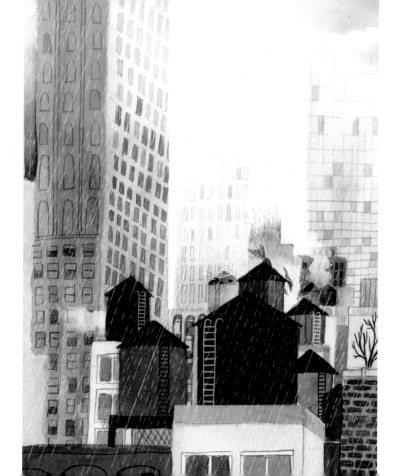

Stenciling

Charlene Liu

Watercolor is just one element of this richly colored and embellished multimedia image, titled *Surfeit's Splendour*. It makes up the sandy-colored background, in which are visible patches of wet-on-wet wash, blooming, and silhouetted diamond grids. The artist used metal fencing and other industrially manufactured products as stencils, placing them on the pre-washed paper and spraying over them with an airbrush. The falling leaves were stenciled in too, with stencils made by the artist. Acetate sheets make good stencils because they don't deteriorate when wetted repeatedly.

The crimson, scarlet, and pink fruit and blossom is made from a combination of photographic screenprint and woodcut printing. These techniques allowed the artist to print multiple shapes over the watercolor background to produce a richly complex and lush image.

Tip If you want to try experimenting with spray and stencil effects, don't buy an airbrush right away because they are expensive. Purchase a spray diffuser or spray bottle instead.

51

Working to a small scale

Daniela Henríquez Fernández

A carefully selected photograph can provide you with a good basis for a small painting. This pink parakeet—one of the more delicate, and smallest, watercolors in this book at only 4" long—was produced using a photograph as a reference.

A hot-pressed paper (sometimes called "smooth" paper) is best suited for working to a small scale thanks to its fine-grain surface. The delicate brushstrokes that make up the bird's feathers require size 1 or 2 round brushes. You can achieve a feather-like texture by rolling a round brush loaded with a little more paint across the paper. This painting, *In Rose*, was done wet on wet, with blooms of pigment on the paper creating extra texture for the neck and head feathers. Elsewhere, the pink mottled marks were smoothed and softened using a small sponge. Contrasting brushwork was used for the black feathers and floral perch. The wings were completed with a more gestural brushstroke, while the detail of the blossom is maintained using a mostly dry brush technique.

Tip Consider scanning and printing your watercolor onto art canvas paper or inkjet watercolor paper if you want it to have a little more surface texture.

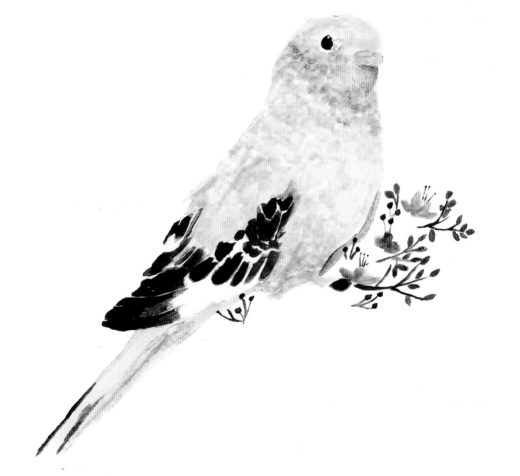

Water-soluble ink

Eleni Kalorkoti

Water-soluble drawing ink, such as was used in these illustrations (from left to right, *Sci-Fi*, *Mask*, and *Reader*), shares characteristics with watercolor paints and you can use them in much the same way. Wet-on-wet washes, dry brushing, and sponging are all featured here, as are at least six different tones of black ink.

To achieve the tonal complexity of a piece such as this requires planning. Premixing these tones in the recesses of a white palette would make this type of painting much easier to complete, as would predetermining the range of tones for each object. Each tone sits edge to edge with another, some with subtle gray lines separating them. The only blending of grays in the whole piece is on the glass in the image to the left.

Tip A smooth surface is best for drawing inks, especially if you use a dip pen. Hot-pressed watercolor papers are ideal.

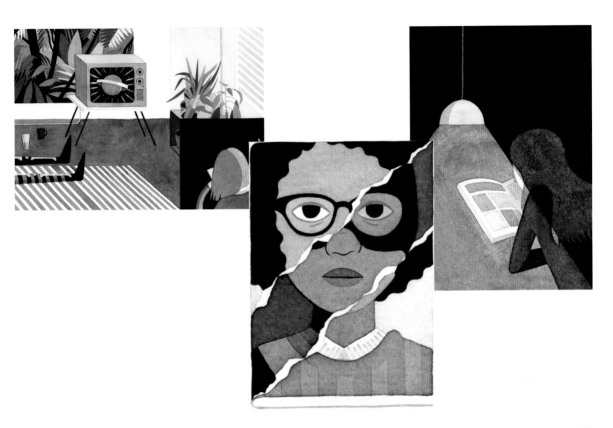

A travel inventory

Wil Freeborn

A sketchbook is central to this artist's work and, with regular travel and working *en plein air*, he has pared down the kit he needs to fill it: a simple travel palette, three differently sized paintbrushes, a battery-operated pencil sharpener, two cameras (one of them is his phone), a pencil, an "artist's pen" (with permanent ink), and spectacles. All of which make for a convenient subject for a painting.

The artist's equipment is painted on the ivory-toned paper of a Moleskine® sketchbook. His approach is to draw a rough sketch on the spot, make color notes, get photo references, and then work up the image at home later. Seeing the artist's tools presented like this helps us visualize the process. Drawing is as important to this image, called *Equipment Page, My Drawing Kit*, as painting; there are visible remnants of a quick pencil sketch in this piece. An artist's pen with permanent brown ink (a subtler, less harsh tone than black) was used to draw in the outlines. Painting was done in several washes, building the tones layer after layer. The travel palette was rendered using wet-on-wet technique—the best method to capture its working surface.

Tip A camera is a useful tool to help you decide on your painting's composition and format. Taking a picture of an arrangement like this and viewing it on screen can often provide you with the information to confidently begin an observational painting.

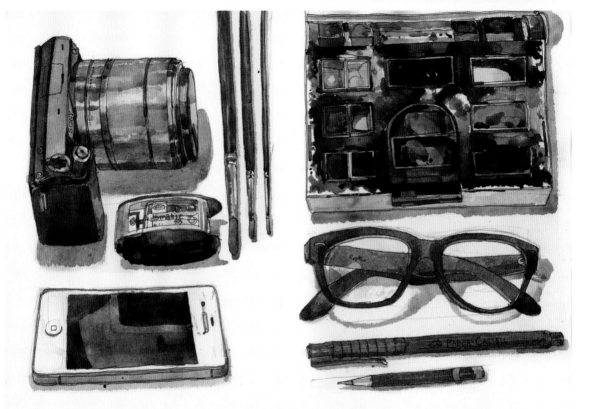

Building detail into a work

Yellena James

Season by Yellena James is one of the more intricate paintings included in this book. The colors suggest something fresh, new, and abundant. The predominance of turquoise blue and green help to evoke a watery environment. The creation of this piece began with the warm background tone—a pale wash applied with a large flat brush, wet on wet, across the whole paper. Other areas of wash were added next with a smaller brush and were allowed to dry in visible puddles, drips, and runs. Tipping the paper, or blowing the paint while it's still wet, can create similar effects.

Next, the artist used these washes to determine the placement and shape of the organic forms before using pen and ink line work to add definition. Once the main boundaries were in place, the more saturated watercolor tones were added—a turquoise blue, and just enough black. Note that these were not applied wet on wet but as dry brushwork. Greater control was needed at this stage to ensure that the color did not flood out of its prescribed zone. Finally, further detail was added with pen and ink and pencil crayon, such as radiating lines, tiny circles, loops and arcs, waves, dashes, and subtle pencil shading over the first wash layer.

Tip Using a palette with several wells, try producing a range of tones of one color by varying the amount of water you add. Tube watercolors and gouache are ideal for this kind of color experimentation.

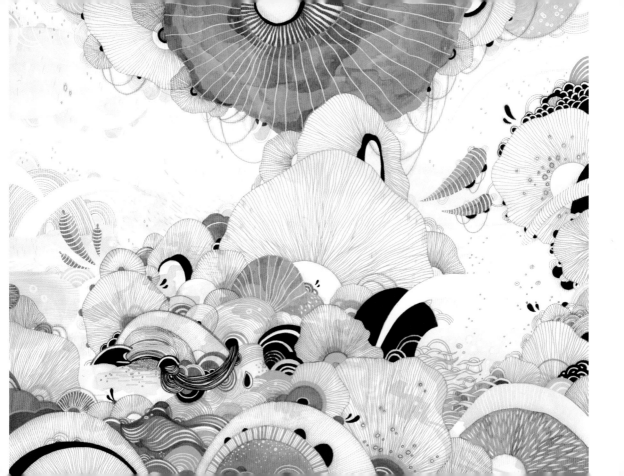

Granulation

Joanna Goss

Looking at this piece, *Your Rustlers*, it is apparent immediately how the various colors of paint have dried differently, with some displaying a texture or granulation effect. This effect occurs when pigment particles separate and settle into the texture of the paper surface. It is a natural property of certain pigments, such as earth colors (raw sienna, raw umber, sepia), cadmium (red), violet/mauve, a variety of blues (cobalt, ultramarine, cerulean), green (viridian), and ivory black.

If you want to achieve the same effect with other colors, you can make use of a paint additive called granulation medium. It will give a mottled appearance to colors that usually give a smooth wash, and if added to colors that already granulate will enhance the effect still further. Look at the pinkish chevrons in this example, which display the particle separation at its most extreme. The artist has used her knowledge of granulation to enliven this design beyond its exciting color combinations.

Tip Colors that granulate are marked on paint packaging and color charts with a "G" beneath the color chip. Many watercolor artists prize granulation effects because they are useful for subjects such as land- and seascapes (to render, for example, clouds, fog, and rocky surfaces).

Achieving ink "blooms"

Lourdes Sanchez

The flowing quality of this ink-based painting, *Ghost Flowers*, typifies wet-on-wet technique, with liberal amounts of water used to achieve the loose, experimental feel. If you want to achieve a similar outcome, preparation is key. With this amount of wetting, a good-quality heavier-weight paper is essential— a smooth hot-pressed watercolor paper will let your color flow more. Have lots of water, sponges, and paper towels handy.

Consider your brush technique. The usual way of holding a paintbrush is at a diagonal to the paper (the Western way). Try an Eastern approach by holding the brush vertically, with the brush at right angles to the paper. Don't use your ink straight from the bottle; instead, think about premixing your colors. You'll need a palette for this—one with deep recesses is good for wet, washy work. All ink colors can be mixed, but be selective.

Tip If you want to work on a completely flat surface, stretch your paper. Any distortion of the paper will encourage washes to "pool."

Creating color shift

Simona Dimitri

Turquoise washes and liberal amounts of water give shape to the background of this painting, *Our Wood*. A pale background wash was laid down, with vertical stripes of blue and green merging into their watery surround. Before it had dried completely, gently leaning diagonals of a slightly darker blue-green were added with a flat brush. The blurring and tonal shifts give depth to the woodland scene. A tree outside the artist's window created a dramatic vertical foreground element to the painting, which cut right through the brighter turquoises. It was made from a mixture of the background turquoise and the crimson of the birdhouse roofs. The birds are also an exploration of that gradual color shift.

Just as a shared color harmony unites the image, so do a series of circles, dots, speckles, and splatters. They act as a subtle counterpoint to the strong lines of the image and within each zone of color—for instance, the pale turquoise dots on the trunk and turquoise dots in the woodland canopy. A little white acrylic is used there too, to help define the birdhouses.

Tip Another way of achieving dots and splatter marks on a painted surface is to lay down your wash mixed with gum arabic. Clean water flicked, dripped, or dabbed onto the dry wash lifts off when blotted, revealing the color underneath.

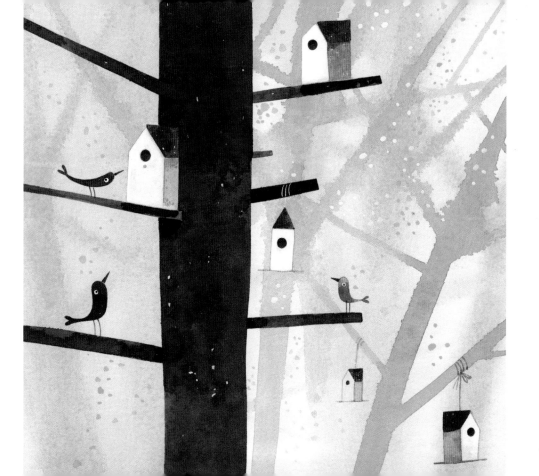

65

Delicate brushwork

Emily Watkins

Watkins is one of the few artists in this book who doesn't use watercolor paper for her paintings. Instead she favors a combination of wet-on-dry brushwork over pencil lines, using fine-grain cartridge paper. This paper has a slight tooth (or texture) to its surface, making it ideal for works with dry media such as graphite, charcoal, and pastels.

This piece, *Garden*, was made for a collaborative summer show called "Explore." A group of artists worked in an open gallery-studio producing work alongside one another, inviting informal chats from those visiting the space. Being part of a group like this is a good way to show work in progress, to share ideas, and to build confidence.

The round frame, combined with the artist's attention to detail and the way she renders detail with fine brushwork, creates the impression of a microcosmic world. Everything is well observed and clearly identifiable, although not necessarilty in the correct proportions to one another.

> **Tip** Fine brushwork can be achieved using smaller-numbered brushes. Surprisingly, fine line work can be made with larger round brushes too—the tip of a good quality sable brush for instance. This is why you mustn't leave your brushes standing in water for an extended length of time: it ruins the brush tip.

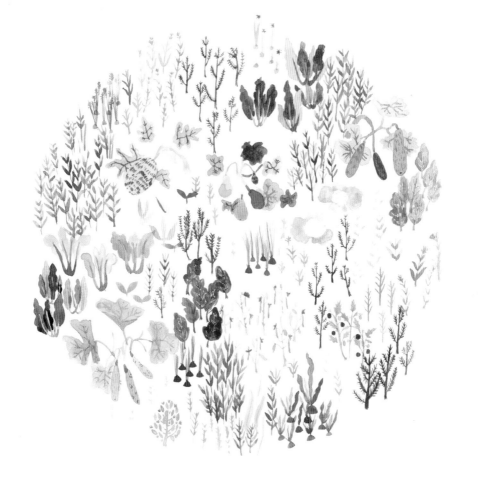

Composite landscape

Kamilla Talbot

At 90 x 88 inches (approximately 229 x 223 cm), this is the largest watercolor painting featured in this book. Its ambitious mural-like scale expresses the artist's wish that this painting be a piece "you could step into." She had painted the scene several times before so was familiar and confident with it.

Unusually, this large composite work, called *Kimmel Road*, was completed outside. Twelve sheets of paper were laid out on the ground in front of the artist along with two watercolor easels—one for the palette and the other to hold each sheet of paper. A job of this size requires a good deal of forethought. The artist had previously done sketches of the composition of each sheet of paper (though she didn't use pencil guidelines on this final version), which helped her when making compositional and color decisions. A palette of color was also prepared in advance.

To paint at this scale, brushes need to be super-sized too. The larger size of the brushes used here makes it easy to track the direction of the brushwork, the to-and-fro of which seems much more physical when it's this large. Paint was applied wet on wet and wet on dry, although its coverage in this piece isn't total—the white paper was allowed to do much of the work too.

Tip It's possible to create a variety of marks and effects with various non-watercolor brushes. Try different brushes for smaller watercolor work too.

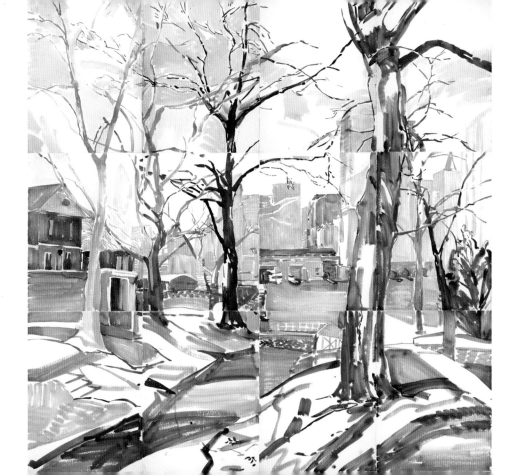

69

Painting household items

Ana Montiel

A kitchen cupboard or an overlooked shelf are often the ideal places to find subjects to paint. In this piece, *The Magical Cupboard*, the artist has used her own collection of mismatched glass pots and jars, filled with herbs and spices, as a source of patterns, textures, and colors. This painting combines observation with experimentation and a touch of playfulness. But despite the apparently simplistic treatment, all is not what it seems. The painting has been produced using a number of watercolor techniques brought together through collage. It would be very difficult to combine these techniques on a single sheet of paper, which is why the collage approach was adopted—it allowed the artist to try out various combinations before committing them to the page.

The watercolor techniques include applying dots of paint on a wet or damp paper (see how the larger yellow and mauve dots flow into one another), adding flicks and dashes of paint on a dry surface, layering color to create a series of tones (evident in the jar of star anise, bottom right), and spraying and stippling paint using a toothbrush. Dots and lines of ink and pencil add definition. The jar of bubbles adds a colorful and unexpected twist.

Tip You could collage shapes from painted pattern sheets by digitally manipulating them or by using scissors and glue for a traditional cut-and-paste approach.

Rapid brushwork

Arthur Kvarnstrom

Several of the watercolor landscapes in this book, this one included, were painted *en plein air*. A striking feature of these is their distinctive brushmarks. Dashes, dots, and quick flourishes of loose to-and-fro diagonals fill the paper. The energy that this approach to painting possesses is clear and the confidence it requires comes from familiarity with the landscape being painted. In this example, the artist visited this place regularly over a number of years.

The spontaneity of this painting, called *Autumn Trees*, is clear. The artist works on several paintings at once, which ensures that no one painting becomes too precious. His aim is to develop a shorthand of marks, distilling the landscape into simple shapes and forms and using colors unconventionally. His impressionistic style captures a sense of how things appear to the mind as well as to the eye. A good-quality "round" (it's actually teardrop-shaped) brush can be used to produce a range of expressive and fluent marks. The middle part, or "belly," is the reservoir in which the paint is held. These brushes respond to the slightest change of pressure and angle, allowing a wide range of marks to be made easily.

Tip The hair, or fiber, of a round brush determines how much paint it will hold and how well it will spring back into shape after use. Sable hair is the highest quality, although hair blends and synthetic versions can be excellent too.

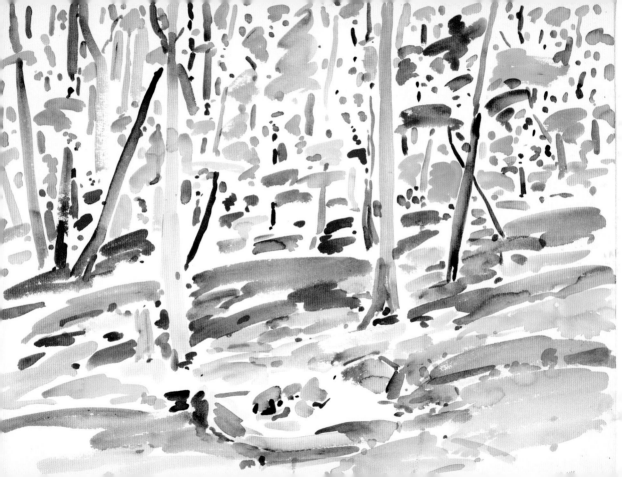

Botanical-style illustration

Gabby Malpas

This detailed watercolor painting, *Gum Leaves*, shares information with us in a similar way to a botanical illustration. For example, the specimen, two branches of a eucalyptus tree, is painted against a plain background so as not to distract the viewer. Using watercolor like this is redolent of botanical artwork: historically, plants were recorded using it, and this painting is a continuation of that tradition.

To present a subject in such a naturalistic way as this requires close scrutiny. Before putting paint to paper, the artist drew everything out in pencil, which enabled her to work quickly with the paint and ensured that the image would look fresh, fluid, and not overworked. She applied wet-on-wet technique with control, allowing the blues and greens to merge as variegated washes and pick up some of the still-damp crimson, which was painted earlier with a finer brush. Some of the red tones were spattered subtly across the painting too. Only once this had all dried were the remaining pencil marks rubbed out gently.

Tip A toothbrush can be used to achieve a fine spattering effect. Making sure the bristles aren't overloaded with wash color, hold the brush a short distance away from the paper and pull the bristles back, carefully releasing them with a finger. Note that a softer result can be achieved by applying the paint on damp paper. Practice on some scrap paper first!

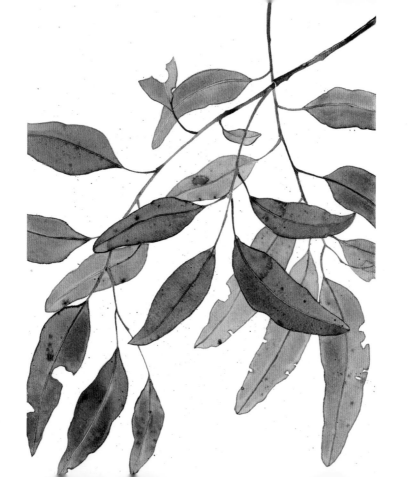

75

Pareidolia

Liam Howard

This painting, *Blue Tit*, makes use of the phenomenon of pareidolia—the tendency among humans to find something recognizable in indistinct forms (for example, seeing an animal or a face in the clouds). By allowing a free flow of water-based materials, the artist then "found" shapes in the image that he later transformed into the bird sitting on its perch.

To create the background patterning, a combination of blue and black ink was poured, squirted, and dripped onto dampened heavy watercolor paper and allowed to merge. Unfiltered water from the faucet was used, causing the ink to separate and creating an effect similar to granulation. Once this was completely dry, a fine-liner pen was then used to create the featherlike pattern. Last of all the bird itself was added in acrylic, with the perch rendered from one of the black blooms of wash produced by the initial application of ink. Lifting out helped redefine some areas.

Tip Color can be lifted out with brushes, blotting paper, cotton buds, or sponges. The technique allows you to correct mistakes or remove paint to create lighter tones.

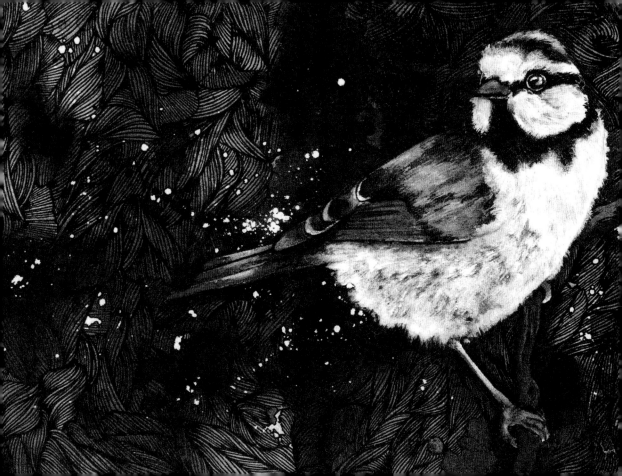

Staining paper

Misato Suzuki

This innovative watercolor illustration, *Paris #2*, takes the rooftops of Paris as its subject and uses a combination of transfer printing, staining, and layering to create a strikingly realized style. For example, a closer look at the blue elements reveal what appear to be the branches and leaves of a tree. These were printed onto the waxy backing paper of a sheet of stickers (the part you'd normally discard), which was then turned upside down, positioned carefully, and pressed gently onto the paper, thus transferring the ink. The artist drew pencil guidelines on the paper to ensure correct placement of the printed section.

The orange-brown areas of the painting were created using an unconventional medium too—coffee. Coffee and tea are good for staining paper and, like watercolor paint, for building up washes. A variegated wash of the blue transfer print ink and a stronger dilution of coffee have contributed to the moody, stormy sky. The way it spills out of the frame adds to the uncontainable effect of the whole painting. A fine brush picked out the individual terracotta chimney pots.

Tip The line work can be drawn using various approaches: it can be done first with waterproof ink so the subsequent layers don't affect it; it can be done last of all using water-soluble media when the other layers are completely dry; or it can be layered in digitally.

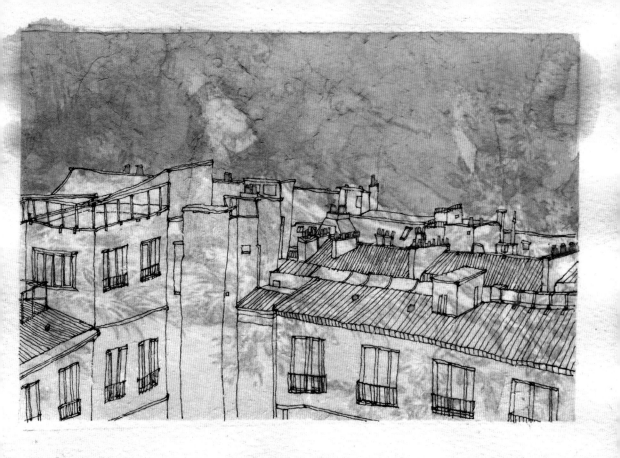

Creating a sense of progression

Sarah Burwash

This image takes us on a journey. It is composed in such a way that our eye is led along a winding path from the bottom to the top of the page, although this isn't necessarily evident at first. First we try to read the image in terms of fore-, middle-, and background. What doesn't initially make sense is the size of the house. Its scale helps us realize that this is an image of several parts, with those parts revealing themselves as the story progresses.

The artist stresses how important research is to her, how finding characters and narratives with lesser-known stories, especially from a bygone era, make her want to create works like this. She uses a dry-brush technique, and delicate brushwork, on flat white paper. The title, *The Fox Sisters*, refers to a story about two women, born into a small farming community in the United States, who in the 1800s enjoyed success as mediums. The earthy tones of russet, red, and brown create a visual link with their family name. The refinement of the brushwork may suggest their demeanor as well.

Tip Using a limited palette can be a good exercise in restraint. It's surprising how focusing on what you want fewer colors to do can be more successful than using abundant amounts of color.

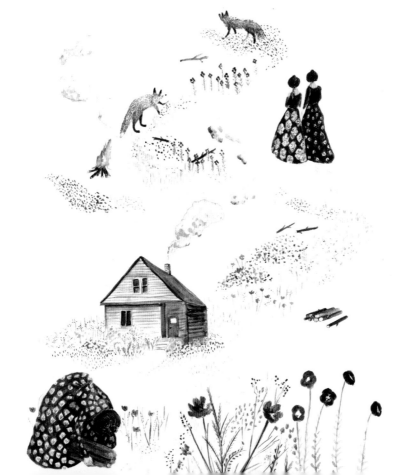

Creating movement

Sasha Prood

This painting of a coral reef, called *Sea Plants*, is united by the harmonious relationships between its colors. Its self-contained circular form, which is suggestive of a planet, works very well. The sea plants and coral forms emanate from a center point, producing outward growth and suggesting movement. The intertwining forms were meticulously researched and were based on photographs and natural history film footage. There is a real sense that the seaweed and coral are living organisms—growing, interacting, moving, and swaying in the ocean current.

This well-planned and complex painting was done using a dry-brush technique and a good-quality round brush with bristles that come to a sharp point, which enabled the finer lines and details to be rendered accurately. The subtle color differences required careful management of the palette. Hot-pressed watercolor paper facilitated the finer brushwork, allowing the medium to flow smoothly across the paper.

Tip Printer-ready, hot-pressed papers are good for printing out scanned copies of your work. Their flat surface is good for photograph-quality prints. Use bright white or natural white paper for the color to be accurate to your original.

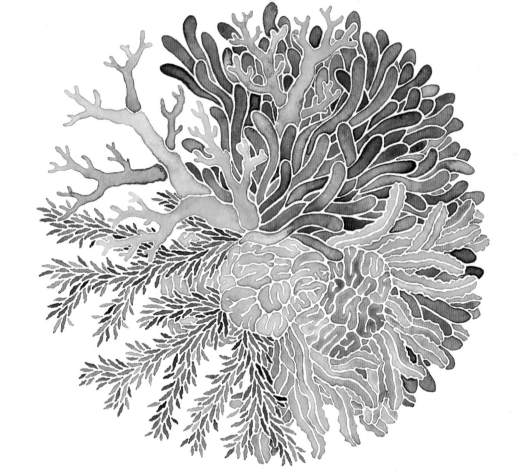

83

Setting the horizon line

Simona Dimitri

In a landscape painting, the horizon line is a key structural tool. Deciding where land and sky meet in relationship to the overall composition can underpin and hold a picture together. This painting, *Red and Grey Thoughts,* has an unusually high horizon line. The land is depicted as a series of chunky stripes of gray, more or less parallel to the horizon with the sky a narrow band of white, broken by the houses sitting on top. Given the fluid brushwork used, a good-quality cotton paper was employed, which provides a much more robust surface. A large wet brush loaded alternately with Prussian blue and black of varying dilutions has been dragged across the dampened page.

The starburst-like marks visible in the wash were achieved by scattering salt onto it, then removing the salt once the wash was dry. Finer details were then added: a girl, birds, cats, heart-shaped flowers, linear patterning, architectural details, and a meandering path.

Tip Experiment with different types of salt on your watercolor painting and see how they react with the various pigments you use. Note that the paper you choose will affect the outcome.

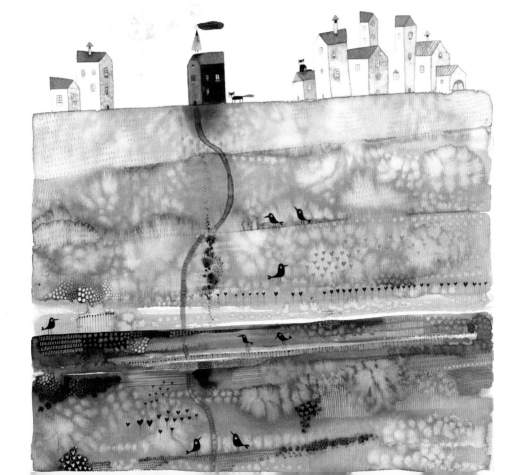

85

Using dye-based inks

Stina Persson

The first thing to note about this painting, *Rosehip*, is the remarkable brightness of its colors, which was achieved using dye-based inks (Dr. Ph. Martin's Radiant Concentrated Watercolor™, for example). Like any ink, these can be used directly from the bottle or diluted with water. Remember though that they are not lightfast so should be used only on pieces that are intended for storage rather than exhibition. If exposed to direct sunlight, their color would fade over time.

The bright red, orange, and magenta of the rosehips in this painting glow against the whiteness of the Fabriano paper. The surface was partially wetted and flowing brushwork was used to lay down colors that run and mix with one another. The very faintest hint of pencil line work provides that extra bit of guidance. Where complementary reds and greens meet, subtle color shifts occur. These are a lovely counter to the intense brightness.

Tip Use a hairdryer or a straw to blow washes around—into or away from other colors. Tilting and tipping your paper can be effective too.

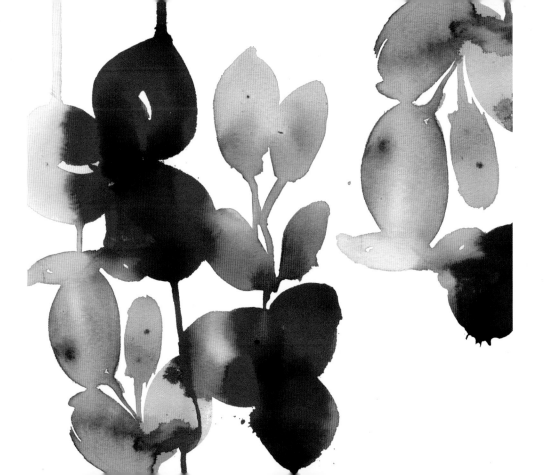

Color influence

David Hornung

This painting, *Red Skiff*, was produced using gouache, a thicker paint that allows for deeper, more opaque layers. As this piece demonstrates, gouache works really well on colored papers and toned grounds. The initial layer of paint, which forms the background, is a warm orange. It imbues the work with a deeper, warmer feel than if the painting had employed a white background.

The background color is clearly visible through the foliage on the right, on the skiff, and as flecks in the grassy foreground area. The green of the grass becomes almost autumnal in hue because of that underlying orange, while the band of blue inside the boat acts as a cool accent and is echoed by the blue of the stone in the center foreground. Finally, small additions of collage enhance the image with areas of flat color adding interest to its painterly surface.

Tip Other recommended painting surfaces for this kind of work might be tinted paper (including colored pastel paper), sturdy handmade papers, mounting board, and other high-quality papers with a slight tooth.

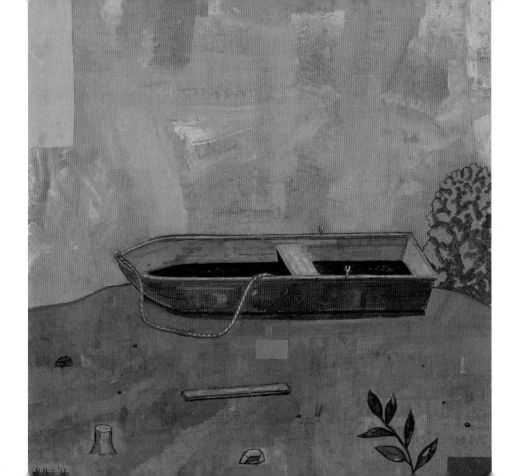

89

Using a geometric base

Nuria Mora

When planning a piece as complex as this it is good to have an underlying framework as a guide and to focus on structure. In this painting, *Flores*, the basic geometric forms provide that foundation. A circle was placed right of center on the paper, within which all of the fantastically complex organic forms were rendered wet on dry using watercolor and gouache. Watercolor was used for the tendrils at the edges of the frame with fine brushwork picking out the featherlike detailing and delicate flowers. Gouache paint was used to create the mass of foliage of the main body, which is larger, more robust, and more "showy." To ensure the colors remained bright and clean, each layer was allowed to dry before another was added.

Interestingly, this artist is also known for producing large-scale works such as murals and 3D site-specific paper works. This hanging basket-like globe of color feels like it could also have been created with cut-outs on a large scale. It's confidently handled and ambitious in its complexity. It feels planned and yet loosely handled, so that the effect is natural and yet designed.

Tip Consider cutting geometric forms into various paintings and colored papers with an X-Acto knife or scissors. Bring the pieces together as a collage. Stick them down permanently or manipulate and reposition them to give you ideas for new works.

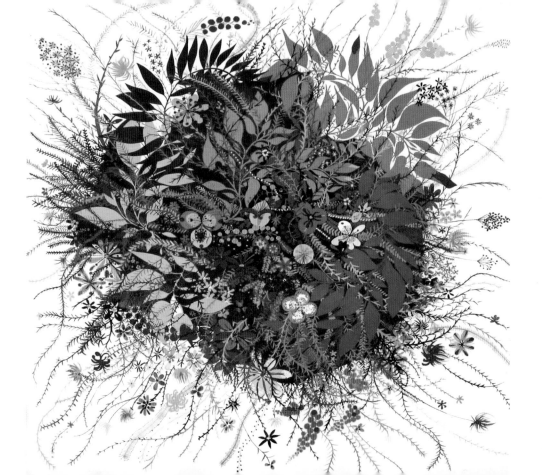

Using secondary colors effectively

Becca Stadtlander

Orange and green, two of the color wheel's secondary colors, are the predominant hues in this gouache painting called *Goats*. They occupy their own areas within the square format, above and below the center line. Using a larger brush, a preparatory tinted green layer was laid down in the upper half of the paper for the sky and a slightly darker tone in the lower half for the fields (and as a general background for the trees). Although green is not the high-key color here, it is the unifying color.

Once the first layer had dried completely, dabs and flecks were applied with a smaller brush to shape the vibrant trees. Their orange tones range from almost red through to a tertiary orange-red and a tinted orange. Note how orange and green were mixed together for the diagonal stripes of the field and for the changing foliage, but not so much that the image becomes muddied. White gel pen highlights were added last to the clouds floating over this rural scene and perhaps most importantly, to the goats.

Tip The rough texture of the 100 percent-cotton handmade rag paper used here is beautiful to work on and adds a special something to paintings that are intended as gifts. Its fabric fibers also make it stronger and more durable than ordinary paper.

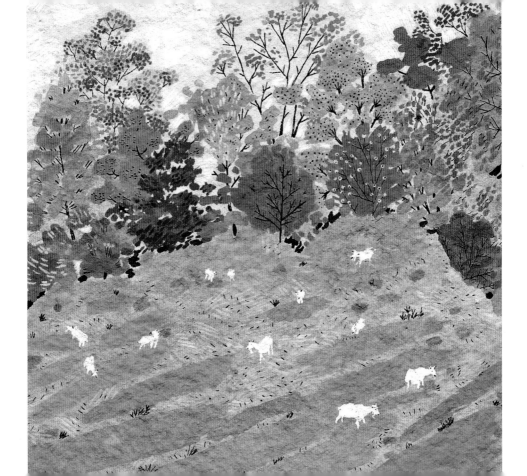

Using a subdued palette

Kate Pugsley

The subdued gray palette of this painting, called *Seeker*, seems to suit the mood of the female figure in it as she gazes both pensively and wistfully into the distance. Nuances of body language and facial expression reinforce the impression. Even the trees and shrubs seem to be in sympathy with this individual as they lean in the same direction as her. This artist often creates an ambiguous narrative and the subdued palette of "almost" color helps the story along. The range of tones used is neutral in appearance and makes no loud statements.

This quiet scene is painted on a wooden panel, its many wet-on-dry layers built up slowly and methodically. Gouache paint was used for much of the painting, which contributes to a flat and opaque finish, while elsewhere acrylic paint reveals more detail, such as brushstrokes. The large rounded forms of the background vegetation balance well with the finer brushwork of the ground level plants. The figure is comprised of the same brushwork but the subtle warm tones of her body and hair separate her from the surrounding cool tones.

Tip If you want to work in layers more easily, or work on different surfaces (something other than paper) try acrylic gouache. It is like traditional gouache but the acrylic binder in it makes it water-resistant once dry.

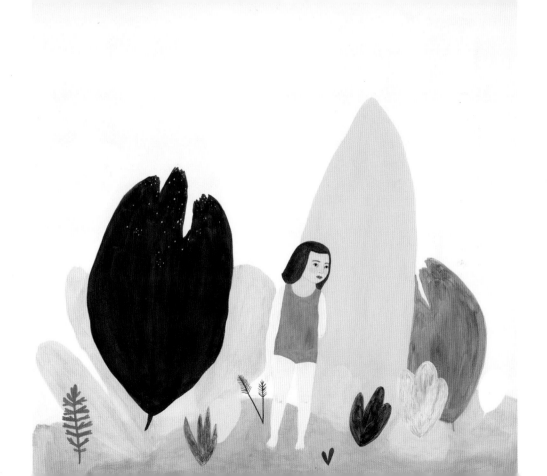

Painting from photographs

Peggy Wolf

I'm not a fan of the phrase "wait for inspiration to strike"—I think it's much better to actively go out and find it. The artist's inspiration for these paintings (from left to right, *Sophie, Isabella, Mirando, Growing Leaf*) was fashion photography. The images are striking for a number of reasons: the poses, framing and composition, and the gazes of the models, whether directed at us or not. All of these elements were determined by the photographs the artist chose to use as references for her four paintings.

Each illustration started as a translucent watercolor painting on thick paper. The strong studio lighting of the original fashion shots ensures good contrast of light and shade. On each of these portraits you can determine the direction of the light. The areas lit most brightly aren't painted at all; the white of the paper does the job. The shadows on the faces, necks, and shoulders, painted wet on dry, reveal a wide tonal range. The clothing was painted wet on wet, allowing the colors to flow into one another to produce the impression of fabric patterning. The vibrant one-color backgrounds frame the models strikingly, with the models' makeup exaggerated for greater visual impact.

Tip If you want to add detail to a wet-on-wet painting, allow it to dry completely before adding more defined or subtle areas. Wet on dry needs to be exactly that, or else definition and contrast between techniques will be lost.

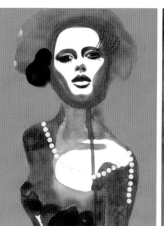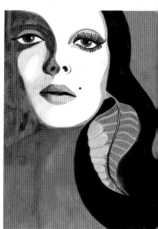

97

Painting for a collection

Eleni Kalorkoti

These pieces (from left to right, *Telly Head*, *On the Blink*, and *Hat Thief*) were produced as part of a wider project, whereby the artist published a zine each month for a year. Projects like this allow artists to track their progress and also prompt them to question how individual pieces can be made to work collectively.

Paintings like this require thinking, planning, and organizing. For this reason a notebook full of *written* notes and observations can be as important as a sketchbook full of *visual* ones. These paintings have two themes: the first features a "telly head" in and on screen; the second is a playful hat-stealing game. The limited color palette—white (from the paper itself), red, yellow, brown, black, plus tints of pink and gray—is a subtle nod to the likewise limited colors of old comic books. This economy of color use also serves to visually pull the images together as a set.

Tip A zine is most commonly a printed, self-published work that can come in a variety of forms—as black and white photocopies or in full color. If printed on good quality paper stock, beautifully made versions are sold online or at specialist zine/artists' book fairs. You can make your own by color photocopying your paintings.

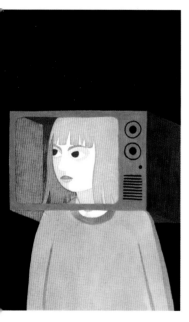
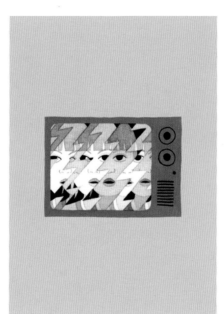

Color and distance

Nicholas Stevenson

This painting, *The Shanky*, was done across two pages of a notebook. It strikes a careful balance between fore-, middle-, and background, and between right and left sides too. The eye is led from the gaze of the woman in the boat to the watching crowd, and back again, before moving to the houses and the mountains. Our attention is led into and through the picture along a zigzag.

The use of color adds to this sense of visual progression. The warm solid orange of the boat is a strong, advancing color, which means it catches our attention first. The blues, used for the water and hilly landscape, are receding colors, which are typically used to depict more distant objects.

Even though the gouache paint is applied in fairly even layers throughout the painting, the linear detailing of the things closer to us—the texture on a pom-pom hat, the ripples in the water, the lines on the boat—create a sense of depth.

Tip The paper in a notebook is "unstretched," which means it may wrinkle a little when wet media is added. The elastic band commonly attached to notebook covers can help to keep this under control, but don't close the book until the work is dry.

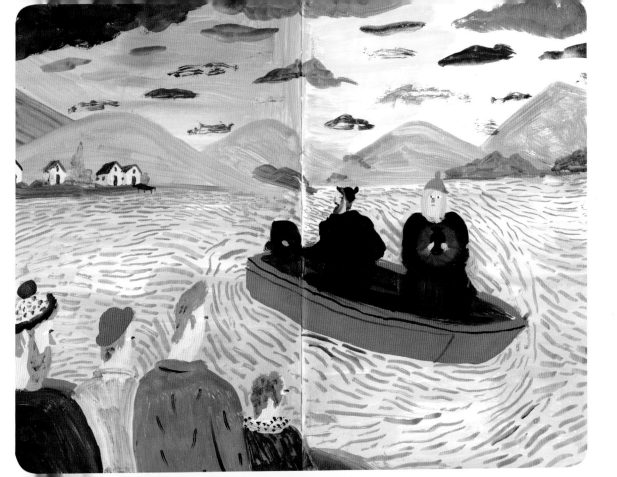

Overpainting with gouache

Vikki Chu

Movement and pattern play an important part in this gouache painting, called *Panther*. A panther strides gracefully through green undergrowth, with the vertical upright plants gently wavering, offering a counterpoint to the panther's strong black diagonal form. The overlapping of objects is central to the dynamic of this piece; if you block out the panther's form it becomes a flat pattern sheet of organic forms. Try it. As soon as the animal is placed back in the frame, behind some of the plants and in front of others, the painting appears as a more three-dimensional space.

The use of opaque gouache paint has allowed for overpainting, even of a lighter color over a darker one. Good use has been made of this here. The panther was painted in first and then the brilliant green and yellow-lime greens were painted over it. The gouache was applied fairly thickly, using a dry brush technique. This is revealed in the broken surface and feathered looking ends and edges to some of the green foliage.

Tip Dry-brush techniques can look very different depending on whether you use a smooth- or rough-surface paper. The more textured or rough a surface, the more "broken" your dry brushwork will be.

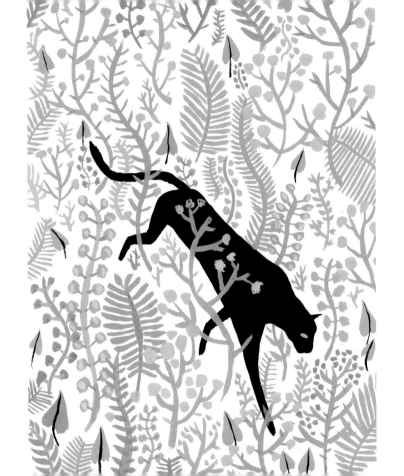

Experimenting with format

<div align="right">

Becca Stadtlander

</div>

A circle is among the least common formats used in paintings, and the choice of a circular frame says much about the way an artist has approached a subject. Look at the depiction of the insect in this example, *Praying Mantis*. Although relatively small, the insect fills almost the entire canvas. The perspective offered by the circular frame is suggestive of a lens, as though the subject is being viewed at close proximity, and is almost scientific in its scrutiny. It also hints at containment, and perhaps estrangement; the insect appears to be in a world of its own.

This gouache painting is different from most of the works featured in this book. For a start, there is no white paper visible and it has been done on a black background, using ink on Arches™ watercolor paper. The artist has used color and shading to make the praying mantis seem luminous against its habitat. White gel pen adds detail and picks out floral flecks within its shadowy environment.

Tip If you don't want to paint a circle, consider instead a vignette. This is a picture that doesn't have a definite border; instead, the unpainted paper creates a border around the composition. The corners are negative spaces that become a part of the design. A vignette can be oval too.

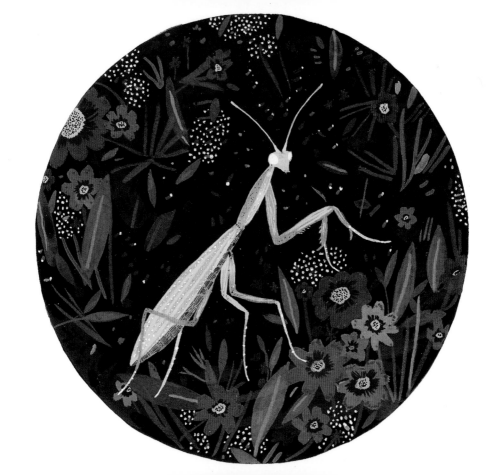

Imaginary landscapes

Koen Lybaert

The creator of these watercolor and gouache pieces (clockwise from left, *Ullerøy*, *Byske I*, *Ketchikan*, *Karibib,* and *Sermersooq*) specializes in "remembered" landscapes. He dispenses with preparatory drawing and instead favors experimentation and his own imagination. Wet-on-wet technique predominates; washes are laid down coarsely with large brushes and the backgrounds, skies, and landforms are painted with great authority. The unexpected format adopted for these landscape paintings—tall rather than wide, plus the unusually low horizon lines—create a sense of drama too.

Each painting utilizes a limited color palette. The washes are graded and variegated and there are lovely moments of flare, backrun, and bleed. They've been used to great effect to suggest trees and foliage, misty areas, and reflections. Other textures are added with experimental brushwork and print marks.

Tip Use a small natural sponge to dampen paper and keep the surface "active" with a plant mister. New textures can be created by pressing crumpled paper, bubble wrap, foil, or plastic wrap onto the paint surface while it is wet.

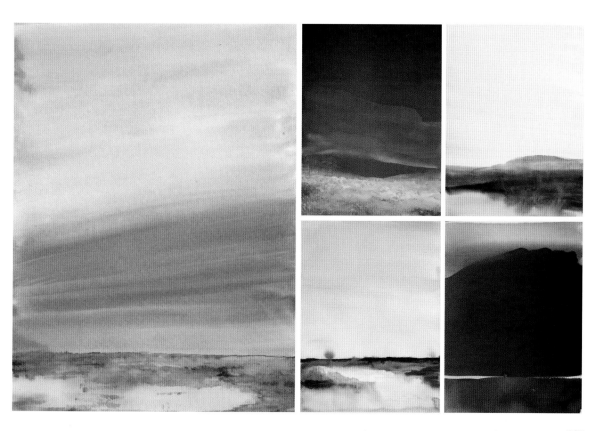

Using greens

Becca Stadtlander

This pastoral landscape painting, *Lily Pads*, uses a wide range of greens, from the lightest, palest wash to an almost black green. The painting achieves a striking harmony, in terms of the colors used and the feel of the scene it depicts. The artist has used a high-quality, 100 percent-cotton watercolor paper that is naturally white (it has no bleaching agents in it) and is strong enough to handle multiple washes of color. She has chosen a squarer format, which is a little unusual for a landscape orientation given that it can make the balancing of elements within the composition more difficult. The painting is structured using a variegated watercolor wash, created by applying different shades of green to wet paper. These shades provide the platform for the land and sky in the top portion, and the lily pond in the lower part. This perfectly balanced format enhances the intimacy and quietness evoked in the scene.

Once the initial washes were completely dry, gouache paint and a finer brush were used to shape the foliage and add the signs of habitation along the center line. Importantly, every new layer was applied to a dry one, thus keeping each subtle shade of green fresh, clean, and separate. Finishing touches, such as the lily pad stems, birch bark, leaf shadows, and windows, were applied with ink and white gel pen.

Tip Try mixing green using yellow and a touch of black. You can create a whole different range of greens than you can make just using the standard combination of blue and yellow.

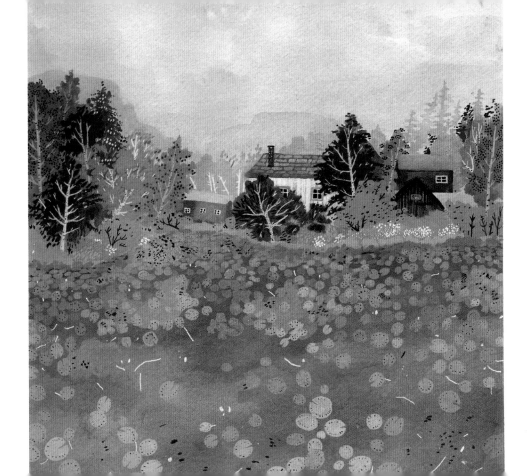

Experiment!

Cathy McMurray

This piece is named *Bloom*, after one of the principle techniques used to create it. A wet wash was left to dry sufficiently so that when more liquid was added the two areas dried separately and at uneven rates, creating the technique's signature blooms, blossoms, and backwashes.

The painting consists of a series of contrasts: between light and dark, organic and inorganic, translucent and opaque, and freehand and ruled lines. A warm cadmium yellow was used for the initial background wash and was applied loosely. A blue-black was then added, wet on wet, at the bottom-right of the paper, creating a smoky effect as it bloomed outward and blended with the yellow. This combination of color acted as an informal structure onto which the details of the painting were added. With the paper still damp, the flowers were drawn with pen and ink. Using a broad flat brush, an incomplete circle was painted with clear water at the bottom-left of the page and the lift-off technique used to take away some of the blue-black tone. A ruler and pencil was then used to sketch out the geometric form near the center of the paper, with many of its panels painted in opaque colors to give the appearance of solidity. Finally, dots and dashes were dropped in using white acrylic ink, and small blue-black triangles added.

Tip Blooms, backruns, backwash, water blooms, cauliflowers, and watercolor watermarks are all variations of the same thing. They're simply areas where extra moisture is dropped into a damp or partially dry area of paint.

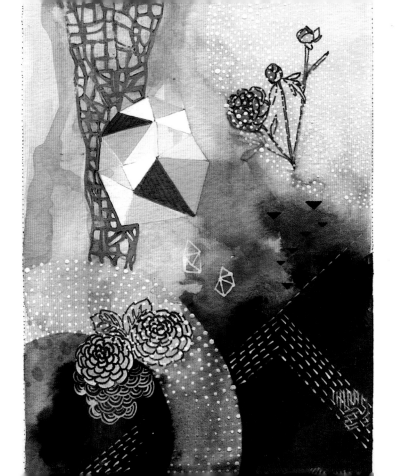

111

Applying color theory

Vikki Chu

This jungle-like habitat is full of outsized creatures and exaggerated, luxuriant plants. Though fantastical they do bear some resemblance to the flora and fauna we are familiar with. They have a mythical quality too, like the drawings brought back from the New World by intrepid explorers. This busy habitat is represented using a limited color palette of red and green, plus black and white. Such a restrained use of color is really clever, especially when you consider the suggested lushness and complexity of the scene.

In this painting, *Jungle*, the artist has applied color theory knowingly and thoughtfully. Red and green are complementary; when used together, they bring out a vibrancy in one another. They are not used at full saturation but instead as tones. This means the colors don't jar the eye and combine more comfortably and naturally.

Other contrasts are used too, such as rough and smooth (the watercolor wash background and flat infills), translucent and opaque, and, perhaps surprisingly, analog and digital. Although the painting feels handcrafted, elements of it were created digitally.

> **Tip** Try something similar with the other complementary colors: blue and orange, and yellow and purple.

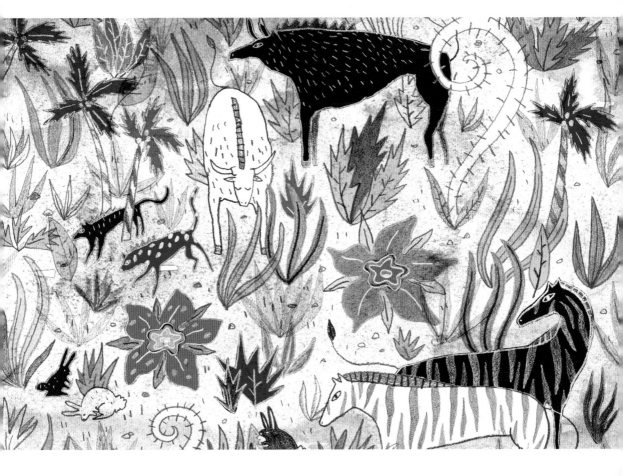

Gouache wash-off

Becca Stadtlander

Set against a dramatic dark background, this painting, called *Matcha Tiger*, features the component parts of a Japanese tea ceremony—tea bowls, a whisk, and a scoop—plus a richly decorated vase of loosely arranged flowers.

A technique called gouache wash-off has been used to produce the bulk of this painting. Firstly, gouache paint was applied fairly thickly and left to dry before a layer of waterproof ink was brushed over it. Once dry, the work was washed with running water re-exposing the colors underneath. Any paper with no paint on it—here the background—remains black, stained by the ink, whereas ink on the painted areas simply washes away under the running water.

There are a few rules to follow to ensure this technique works well: work on a stretched heavy paper as it will be soaked with a lot of water and stretching will ensure it stays flat; plan your painting before you start, drawing simple outlines in pencil; don't layer the gouache—a single thick application is best; and use warm water to wash the ink off.

Tip Get to know your paints well and experiment with a wash-off color scale: some pigment colors will wash off more quickly than others. Warm water will wash the ink off faster than cold water.

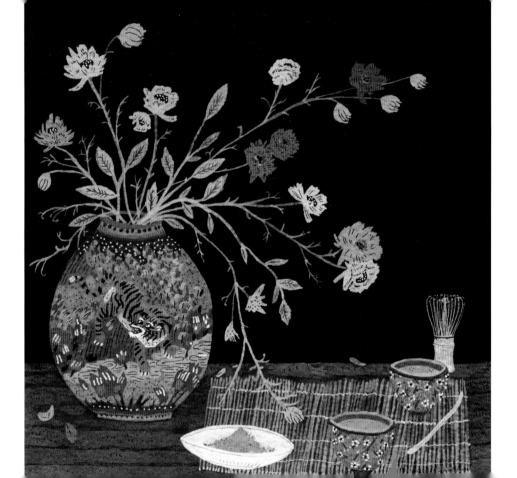

Earth colors

Natasha Newton

Ocher, sienna, and umber are among the paint pigments produced using extracts from rocks and soils. These paints are typically available as yellows, reds, and browns. In this painting, *Night Rain 2*, the artist has used these tones to depict a mountain range at night. The earth colors, plus black, combined with the dots and small dashes, are perhaps a little reminiscent of indigenous Australian art.

The three peaks have a patchwork quality to them, with watercolor used to infill an ink-pen framework. Some of the paint was applied wet on wet and some wet on dry, with lift-off technique used to create highlights. Remember that the coarseness of the watercolor paper will affect the way the paint dries.

The white patterning, which gives shape to the rocks and also indicates rain, was added last. An opaque paint was used to allow for the details to be applied over the darker tones. Gouache and acrylic ink would do the job, along with a paintbrush or dip pen.

Tip A basic watercolor palette should contain earth colors—raw umber, burnt sienna, or yellow ocher are good examples.

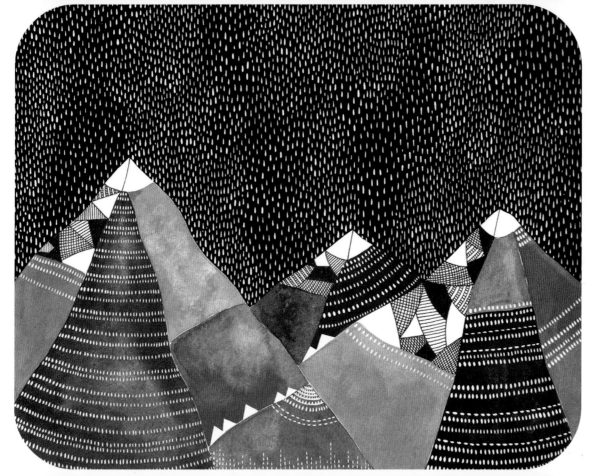

Using sketchbooks

Nicholas Stevenson

Some artists may be reluctant to use a sketchbook for paintings, perhaps for fear of damaging other work inside. The artist behind this piece *Chase*, however, delights in describing how he made it with "very wet paint and mostly very thick paint." He was not concerned with anything but getting his idea down on paper.

In the first stage of the painting's development, a large paintbrush was used to lay down a loosely applied, uneven gouache background. As the blue paint began to run out, the artist simply added more water to ensure quick coverage of the remaining space, resulting in a lighter tone. The trees and people are painted with a similar spontaneity, but here the gouache is laid down with a smaller brush. The paint has a creamier consistency because it has had less water added to it. Accidental fingerprints are incorporated into the image—look at what the woman in the red dress is standing on, and at the smudging on left edge.

Tip A light coat of white acrylic on the reverse side of a watercolor sketch will allow you to safely use the back without "bleedthrough."

Capturing water

Jeannie Phan

Sometimes, the subject you're planning to paint will dictate the technique you use to paint it. In this example, called *Pool Day*, wet-on-wet technique proved ideal for capturing the fluid motion of water in a swimming pool. All that was required was confident and, importantly, quick brushwork. A distinctive feature of this painting is the bend in the pool. The artist was commissioned to illustrate a newspaper article about incorporating swimming into a daily routine—the upright section of the pool suggests it can be an uphill struggle.

The wet-on-wet technique was laid down in stages to allow for the "fold" line in the water. Ultramarine blue mixed with a little cadmium red produced the color of water in the swimming pool. After this, gouache paint was used to render the swimmers and the pool's tiled edge. Its opacity made it possible for the swimmers to be painted over the blue, although this does create slight differences (look closely at the man doing a backward dive). Lastly, fine red and white line brushwork sharpens the details.

Tip Compare this piece with the painting by Monica Ramos, *Warm Water* (page 32).

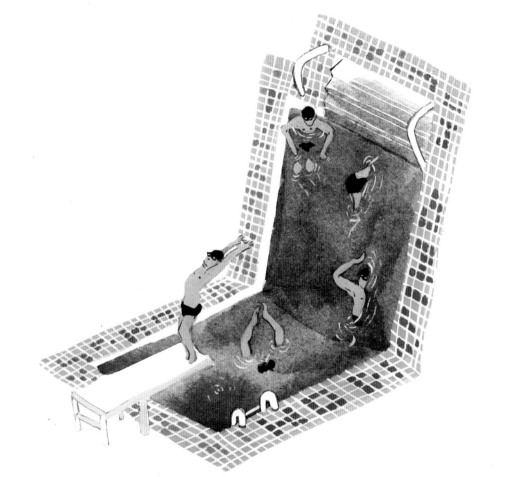

Creating a stylized painting

David Hornung

The objects in this painting—a tree, a wall, stones, and a snake—are rendered in a way that gives the work an allegorical quality. Their highly stylized appearance is particularly evocative; the sun, reminiscent of something from a medieval manuscript, echoes historical art techniques and adds further layers of possible interpretation. The objects are starkly outlined, perhaps to emphasize the strength of the sunlight. The contrast is striking between the details that are top-lit and those that are not. The only suggestion of movement in the scene comes from the slithering snake and the slow-moving sun.

The painting, called *The World We Live In*, was produced using gouache laid down in broad downward slabs of color. The handmade paper used was made with a base tone of yellow—a perfect color for a subject that examines the cast of light. Even though the paint is opaque, those later layers are tinged with a hint of yellow, which unifies the disparate objects, as does the image's use of color harmony— yellow, green, and blue.

Tip When overpainting there is a danger that muddying can occur. Adding gum arabic or extender medium to gouache paint during mixing helps create a water-resistant layer of color. It can also create varying degrees of transparency, if required. Don't add too much though as this will result in a glossy surface prone to cracking.

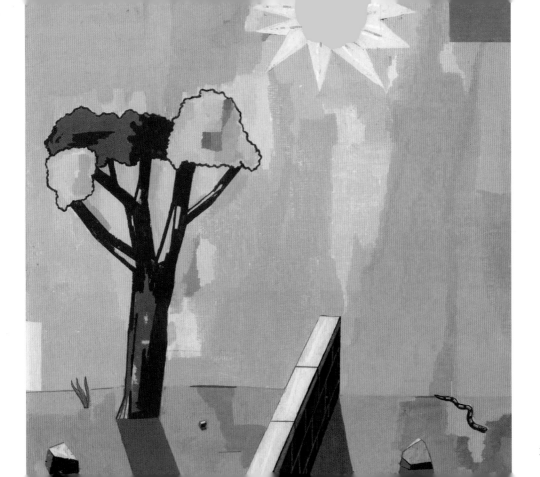

123

Mixing media

Blanca Gómez

This image, *Sun*, has instant appeal. We can't help but respond to its immediacy; it possesses the quality of a children's book illustration. Watercolor and digital techniques have been combined to make this seemingly simple illustration, although the mixed-media approach is not initially apparent. A large flat paintbrush was used to apply a yellow-orange wash to a sheet of cartridge paper, with the brush marks remaining visible. The wetness of the application made the paper pill a little, whereby the surface began breaking down and small rolls of paper were formed—a common occurrence when watercolor paper isn't used. In this case, however, it didn't matter because the artist simply wanted to make a painted surface she could scan.

The outer edge of the image is a perfect circle, and the same is true of the small white dots that represent the sun's rays. The white interior circle was drawn imperfectly, to match the imperfect wobbly sun sitting happily in the middle. This is complemented by an imperfect hand-painted look, which the artist achieved by digitally manipulating the image. The bright-orange cheeks and simple features have been left unblemished.

Tip Consider using stencil masks on your painting. These can be stickers you remove once the painting is complete or paper with suitable shapes cut into it through which you dab paint.

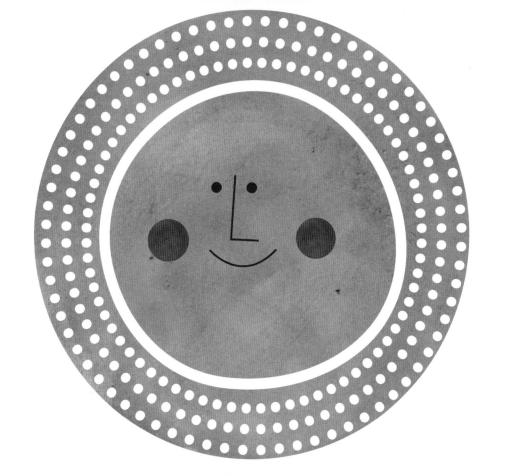

125

Using software filters

Patrick Boehner

All is not what it seems in this image, *Cardboard Swimmer*. Despite the presence of what appear to be watercolor washes, it is in fact entirely digitally manufactured. An old, water-damaged piece of corrugated cardboard was scanned (the flattening of form and the way light has fallen on the surface are telltale signs of a scanned image) and used as a digital canvas. The subject of this piece was taken from a photo and manipulated digitally. Look at the various tones of gray on the waterpolo player's arm; these are a product of the posterize filter in Photoshop. The same is true of the paler tones of gray used for the submerged parts of the body, the boundaries of which are more blurred.

The hard, clean lines of the digital image remain to help define the figure both above and beneath the water. The cap is left as it is—fine gray details on white. It would be difficult to attain such clean lines and clarity of color by hand, especially on what is apparently a soft, old piece of packaging cardboard.

Tip Both painting/drawing apps for smartphones and tablets, and more sophisticated computer programs provide tools that mimic traditional watercolor. Their brush palettes provide various width, texture, and edge settings. You can also lower the opacity of your "brush" so it creates the transparent look of watercolor.

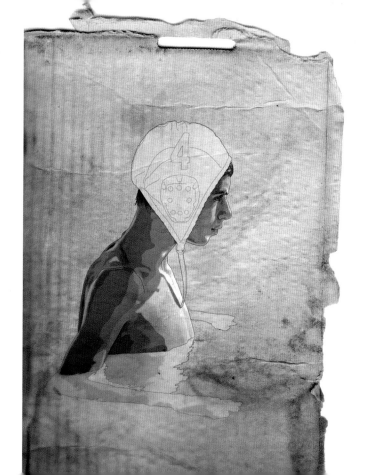

Enhancing ink digitally

Helen Dealtry

This exuberant expanse of brightly colored cacti combines watercolor inks and digital manipulation to great effect. The ink was applied with variously sized brushes and a sponge applicator, allowing for a surprising variety of marks. In this painting, the broken texture of the flowers and the spines of the cacti were most likely achieved with an upright dabbing motion, and the wash of the paddle-shaped cacti forms with a combination of the sponge applicator and brushwork. The main cactus in the center was then repeated either side digitally—as mirrored and reversed versions—adding important visual interest to the image. Finally the complementary pink background was added.

The effectiveness of a work is often determined by the planning that went into it, and the colors in this piece, *Candy Cacti*, have been thoughtfully mixed and combined. The predominant pinks and greens were premixed using a pipette to transfer ink from the bottles to the palette. When mixing inks, a deeply recessed palette is useful. Glass or plastic containers work well too. Go for white or transparent containers as this will enable you to see the color more clearly.

> **Tip** A colored background will affect the appearance of translucent media. This can be achieved either through the application of a color wash or by digitally "dropping in" the color at a later stage. The latter is a useful (and safe) way of trying out a variety of colors until you have found the right one.

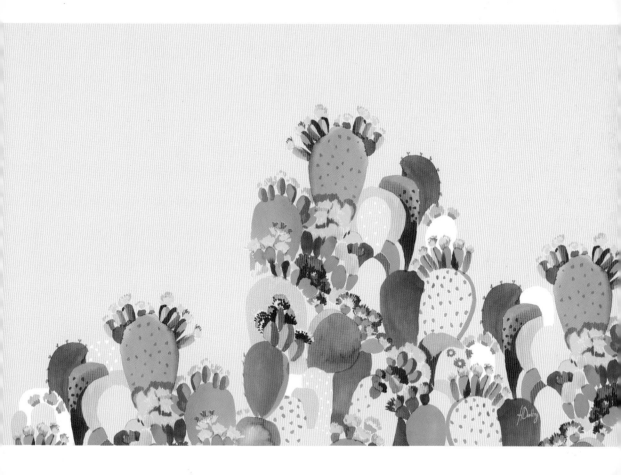

Using template outlines

Ekaterina Koroleva

Many watercolor techniques are used here: wet on wet, variegated wash, color backruns, salt texture, granulation, plus tilting, and spilling. This wide range of techniques is manageable because the painting, called *KIDZ*, was constructed using digital manipulation; its various components were layered, arranged, and adjusted until the parts worked together.

Look at the three deer. They're actually all the same basic drawing manipulated to look in different directions. Also, the flow of the wet-on-wet color, specifically the granulated red-orange of the deer seems to stop short. There's a paper space between them and the goat in the left-hand corner. These details hint at the digital collage techniques used here. The digital elements are handled so subtly that it's difficult to tell them apart. The painted loops of orange-green on the left are digitally layered on the right. The salt texture in the center doesn't dominate because the large deer is digitally collaged over the top of it. The black ink drips and lines pull everything together.

Tip Don't be hesitant about using digital means to enhance your watercolor work. There are several pieces in this book that do the same, and probably more elsewhere that you didn't realize did too!

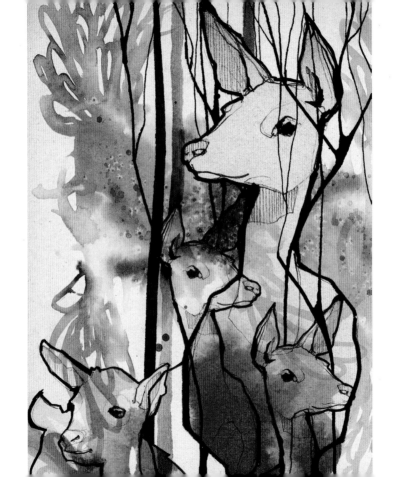

Painting birds

Functional Fox (Matt La'Mont)

The three birds depicted in this piece, *Night of the Warblers*, were created through a combination of watercolor techniques and selected photographic elements put together digitally. The result is an image with the flat surface of a gouache painting.

The image is set up in portrait—an unusual compositional space for a wildlife image. The birds' environment is blank and neutral, which focuses our attention on their plumage—a subtle variation of browns and grays. To suggest texture, the clean edges of the main feathers have been dragged and pulled. Scratch-back or sgraffito-like marks are used for the lines of exposed downy feathers. On closer scrutiny, it becomes clear that the three birds are variations of the same image. Although the colors were changed, one bird was reversed, and one scaled down; look closely and you will see that the feather patterns are the same.

Tip Try blowing wet edges of paint through a straw or even with a hairdryer to create interesting edges and run-backs. Make scratch-back/sgraffito marks in paint with the wrong end of a paintbrush or the corner of a card.

133

Achieving a "crafted" digital look

Dadu Shin

There's something inherently pleasing about this piece, called *Plants 2*. The warm color palette of orange, pink, and crimson used to depict this collection of cactus-like plants works well against the rich creamy background. The tones of each plant stem and antler-like shoot are built up in incremental layers, from light to dark, varying between two and three layers in depth. At the points where one cactus overlaps with another, intermediate tones are created.

Although this piece looks like it was painted, it was in fact digitally rendered. The texture of a cold-pressed watercolor paper seems to reveal itself beneath the "painted" cacti and the broken black lines sprouting from their base. The blending and shading on the main stem suggest watercolor pencil work. All of which indicates that the artist has gone to some length to make this image seem hand-rendered. Only the perfect curves of the container and the clean edge of the magenta-colored part of the front cactus perhaps reveal all is not what it seems.

Tip Using tinted papers can make a real difference to a work. Remember though that even a subtle tint can affect the "true" color of translucent watercolor paints.

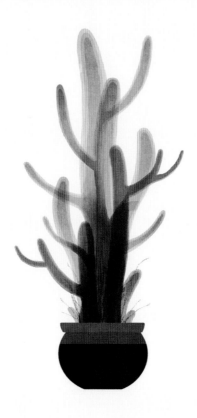

Dramatic panorama

Georgiana Paraschiv

The hard-edged geometric forms at the center of this piece, *Pink Sun*, are provocative and dynamic. A large, perfectly round bright-pink sun dips just beneath a range of black triangular mountains. The mountains' deep, inky-black color and sharp edges strike a note of tension and drama. The sun's size, relative to the mountains, exaggerates this. The atmosphere is complemented by the textured swathe of clouds that appear to float before it.

This piece was produced using mixed-media techniques. First, the base paper was stained gray and allowed to dry unevenly (areas of darker gray are visible where the paint pooled before drying). A stripe of darker wash was added, wet on wet, to create a cloud bank behind the mountaintops. The sun and mountains were rendered digitally, although they do incorporate scanned layers of translucent paint, which accounts for the textured, inconsistent quality of the sun and the second range of mountains visible just behind the first lends the work a print-like quality.

Manufacturing a watercolor image in unconventional ways such as this increases the creative possibilities available to the artist.

Tip Try specialist paints—fluorescent, pearlescent, or even glow in the dark—for more unusual painting outcomes.

Using illustration software

Kotryna Žukauskaitė

With this piece, *Late Night Coffee*, the artist set herself the challenge of mixing digital and handmade techniques and finding the fastest way to produce digital artwork with a handmade collage appearance.

A mixture of watercolor and ink brushed, wet on wet, onto white paper created the metallic surface texture of the coffee pot. The inconsistency of the wash, with pooled and stippled drying marks, proved ideal for the job. These texture sheets were scanned and used within the illustration program Adobe Illustrator as "swatches" to fill an outline of the coffee pot. The image's details include a stylized heat source, a central band of stencil patterning, and a suitably geometric steaming spout. Setting the pot against a slightly textured background added a handcrafted feel to its stylish "designer" look.

Tip The name "swatch" was originally given to a sample of cloth. Today, in Photoshop and Illustrator, a swatch is a color or texture you save for future reference. You can use these swatches to select those colors, textures, and patterns quickly, without having to repaint them again.

Telling a story

Helen Hallows

Having a more intimate knowledge of a place can often encourage us to create images that tell more of a story. The objects in this painting, *A Slow Spring,* are less about a place and more about a set of experiences. The gray background wash sets the scene while concentric circles of light from a pale sun radiate out, barely dissipating the gray. Objects are sized according to their importance in the narrative rather than to our expectations of them. A bird's nest is larger than a tree; clouds and a rainbow seem to be at ground level; and a flowerbed appears to float in place of the clouds.

The painting brings mixed media and layering techniques to paper that would more usually be found on an appliquéd fabric piece. A variety of watercolor techniques were used: wet on wet, staining, and bleaching (this latter technique "knocks back" the color; it is used, for example, on the tree and for the rain). Collaged "found" papers, inked-in details, and machine stitching all combine to create a richly textured, visually interesting surface. Subtle use of tinted colors suggests the dampness of a spring day, poised to eventually bring the bolder colors of summer to her garden.

Tip Use an unthreaded sewing machine to punch holes in paper, before or after painting on it. Held up to the light or exhibited on a light box, some interesting effects can be achieved.

Using primary colors

Marcus Oakley

Any painting that consists entirely of primary colors is going to look raw and perhaps even childlike or naive. This is because it is rather unusual for us not to mix colors to create new ones. Various techniques and approaches were utilized in making this work, *Still Life*, including painting, drawing, cutwork, and collage. Masking tape was laid temporarily across the board just above the halfway mark and scarlet ink was added up to this line. The three items—the houseplant, small cacti, and pine cone—were painted separately, cut out, and then brought together as a collage. The paper they were painted on has a different surface to the acrylic board. Color doesn't sit on it in quite the same way. The blue brushstrokes are particularly visible where they have soaked into the paper surface. The artist has made no attempt to smooth them over. Where it was overlaid, translucent color has overlapped in this spontaneously made image, revealing a glimpse of secondary colors.

Tip For paintings of this kind, use a natural, unbleached white surface, without optical brighteners, which could adversely affect the bright colors.

Collaboration

Sandra Dieckmann / Jamie Mills

This piece, *Turtle*, which is one of a series about endangered animals, was a collaboration between two artists. Each artist had responsibility for specific elements in the scene: Jamie Mills produced the corals, rocks, and waving seaweed, and Sandra Dieckmann was responsible for the turtle. Because the image is mostly limited to black, white, and gray the different styles and media work well together.

The turtle's shell is comprised of chromatic grays (grays that contain a hint of another color). Watercolor was washed onto paper that had been scrunched up and then flattened out, resulting in interesting surface patterns. These painted papers were then scanned and edited in Photoshop before being digitally arranged to fill the outline of the turtle's shell. More wet-on-dry tones were added to the reptile's legs. In marked contrast, the sea floor is drawn in richly textured, dark pencil tones of black and gray. Bright blue, opaque red-orange, and translucent yellow seaweeds grow from it.

Tip Chromatic grays, made by combining gouache paint in two complementary colors with white, cover a wide spectrum of possible variations. Try ultramarine plus burnt umber. Add more blue for a cool gray and orange or red for a warm gray. Make color charts and tonal scales as a record for yourself, and annotate your findings.

Selecting paper

Tracie Huskamp

A large factor in using watercolors successfully is understanding the surface on which you are going to paint. It is important that your paper is absorbent enough, or stretched, so as not to buckle and distort as wet media is applied to it. In this painting, *Leap*, the papers are used as a reference, and as an accompaniment to the painting, which is the rabbit in the center.

The miscellany of found papers includes an antique, ink-stamped sheet, the torn edge of a printed journal, an archive notebook page, a portion of pattern-printed tracing paper, and a roughly cut out fragment printed with a galleon motif. This combination of collage and painting succeeds because the collection of historical papers provided a reference color palette for the rabbit. The painted area was built up in layers, the tones matching those of the paper collage. Some were applied wet on wet, some wet on dry. The artist has used a blending in, dry-brush technique called scumbling. It has left telltale brushstrokes that are ideal for the texture of the rabbit's coat.

Tip Use scumbling to create a fine mesh of opaque pigment over another color, making it less bright and dominant.

147

Reworking an old painting

Valéria Kondor

Occasionally artists create something quickly and impulsively, without a great deal of planning, reacting instead to what feels right at the time. Rather than dwell on details, they're keen to get visual ideas down. This image, *Nothing Compares to Play*, began life as a very lightly painted watercolor with an architectural theme. The artist wasn't altogether happy with it so stored it away unfinished. Two years later the sheet was taken out again. It was reworked with weightier black-gray tones and elements of collage. On top of this paper elements were added. That collage effect can be seen most clearly in the white organic form at the bottom right and the small white arched windows top left. Abstract shapes of loosely painted gray gouache sit on top, some with dry brush edges. Further finer details were added with chalk lines, wet-on-wet blue bleeds, sgraffito lines, and dots and dabs of white.

Tip When adding layers of gouache, be aware that its tone tends to change as it dries. Lighter tones more often dry darker, while darker tones tend to dry lighter.

Adopt a playful style

Marcus Oakley

This painting combines playfulness with an assurance of touch that comes only after much practice and patience. The artist has spent time learning what works for him, and this is very much in evidence here.

The starting point for this piece, called *Big Hair*, was the face, which was drawn right in the middle of the page using watercolor pencil. The lines are chunky and firm, and no guidelines were sketched out first. There is a particular styling to the features—perhaps a little Byzantine; perhaps a little Picassoesque. It certainly has a retro feel to it.

The dramatic hair—somewhere between the colors burnt sienna and Venetian red—was painted onto a separate sheet of paper and, once dry, was shaped with scissors. The roughly rectangular dark-blue clothing was added in a similar fashion. The carmine cheeks were added last.

Tip Don't waste your paint. Use spare tube or palette remnants to stain and paint paper. Have a collection of these saved for collage work such as this. You may want to keep a more formal record of your painted paper chips too, with notes reminding you how you mixed particular colors, what brand the paints were, and so on.

151

Collage with embroidery

Julie Van Wezemael

This whimsical image of a cat with strangely human characteristics, called *Birthday*, was constructed in a suitably lighthearted manner. Its clothing was made of found papers, some selected for their printed pattern and others because they provided scope for further embellishment. The cat itself was painted with washes of black acrylic paint and its collaged outfit was enhanced with gouache paint and fabric and thread. Machine embroidery adds definition to the fur on the cat's head and also the feathers of the bird that the cat is holding. White colored pencil picks out the cat's eyes and is blended into the cheeks to add shape. The various pieces of found paper were cut into shape with an X-Acto knife and then arranged on the paper, with further cuts made where necessary, before being fixed in place.

Incorporating elements of mixed-media collage into your painting may encourage you to be more experimental with your paint. Anything that doesn't work can simply be cut away.

Tip Don't try to cut your painted and stained papers if they are still wet or damp as they will more than likely tear. Let things dry thoroughly so you achieve clean, sharp edges when cutting.

Using "found" materials

Kasia Breska

The intention of this image, *I Found Them Upon the Nobody Place*, is to convey the sense of a place in different way to one we're used to. The artist sees this mixed-media image as a landscape, one she has experienced, discovered, and constructed but has chosen not to render in an observational manner.

This is a landscape constructed from samples found within it. Some parts are from close-ups captured with a camera, others are drawn from samples taken back to the studio and viewed with a microscope. Even the river water collected on these trips becomes part of the mixture for the background spill and tip washes, and as a dilution for the watercolor pencil work.

The flowing background and triangular prisms contrast well. The outlines of the blue crystals have been drawn freehand with a pencil, which makes their geometric lines seem a little more natural. The modulated blue infills retain the marks of the watercolor pencils that made them, softened by a subtle blending with a brush and the river water. Small pieces of envelope collage and sections of tracing paper enhance the patterned surface.

Tip Much emphasis is placed on purchasing the right paper for watercolor painting. Be prepared to experiment and work on "incorrect" surfaces. You might like the results!

155

Painting a pet

Itsuko Suzuki

In this painting, *Borzoi*, a Russian wolfhound gazes dolefully at us. Its portrait has been completed quickly, not in order to capture its likeness before the dog moves but because this is one of the artist's signature styles. The artist makes this fluid, almost childlike dog portrait appear easy. Cream and pale acrylic washes were applied carefully, wet on wet, with a broad brush to form the bulk of the borzoi's head and shoulders. Subtle modulation of tone gives it shape.

Wet on wet was also used for the dog's bluish eye patches and black nose, whereas the more defined coal-black eyes look as though they were added later, after the wash had dried. The final details were then added using blue watercolor pencil, with flecks creating an impression of fur and outlines adding definition to the eyes, ears, and nose.

Tip If you want to increase the flow of an acrylic color in order to imitate a watercolor effect, use acrylic flow improver rather than water. It slows the drying time slightly and also limits color loss.

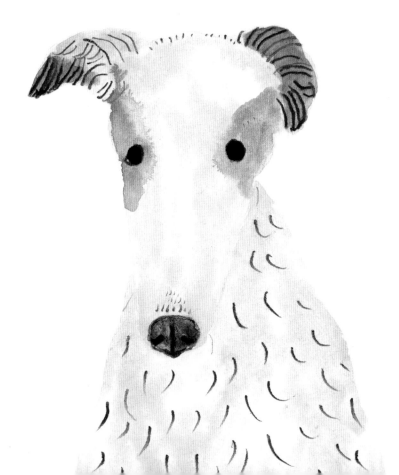

Alternatives to watercolor

Sandrine Pelissier

A watercolor effect can be achieved with other media. This painting, *Morning Walk,* used liquid acrylic, which is a good alternative to watercolor paint when using an unprepared canvas. The important difference between an acrylic medium and a watercolor is that the former is waterproof, which means certain watercolor-style techniques won't work once acrylic has dried.

This forest scene has been painted quickly, with pencil guidelines left in place, while the surface is still active (i.e., wet). The rapid workrate is evident in the backruns (sometimes called cauliflowers) of color, which occur when a fresh color is added to a wash that isn't dry. When using this effect, it is important to consider color combinations; this painting uses harmonious tones of green and blue (they are right next to each on the color wheel). A warm, reddish tone was used in the mix to bring the brighter colors together in a more naturalistic, but not too muddy, way. Krylon Workable fixative and varnish were used to make the image exhibition ready. Mixed media pieces often have less stable surfaces so it is a good idea to use something to fix, stabilize, and protect them.

Tip The planned white spaces of this painting are an important part of the design.
Pre-prepare your surface with masking fluid or torn masking tape for similar looking
organic shapes. Both can be removed once the painting is dry, exposing the "original"
white of the surface.

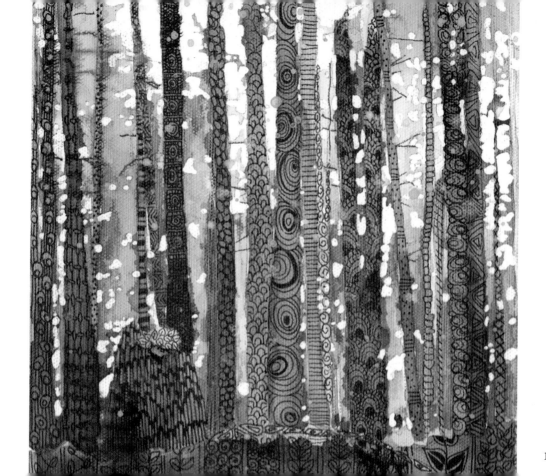

159

Innovating with still life

Junyi Wu

Using houseplants for the subject of a still life is common enough. More unusual is to pull them carefully from their pots so that their roots become part of the painting, as has been done in this piece, *Roots*. Interestingly, the artist has decided to exclude a table or some other surface on which to place the plants. Each plant is suspended in white space, a little like butterflies would be pinned in a case or specimens laid out in a museum display, thus encouraging closer scrutiny.

The image was made dry on dry using layered, crosshatched, and blended watercolor pencil on a smooth white BFK™ paper (a printing paper that doesn't distort when wet). Clean water was then applied using a fine brush to strengthen the tone of the yellow roots and the darkest blacks. Because water was only used minimally, the pencil marks were maintained, meaning that these studies sit somewhere between painting and drawing.

Tip It is important to know how soluble watercolor pencils are when you buy them. Softer ones blend more easily and act more like watercolor paint, while harder ones provide weaker washes but are good for fine work.

Mixing watercolor and acrylic

Paul Bailey

The dynamic brushstrokes, paint mixture, and the gesso surface preparation make this landscape painting, *Welsh Farmhouse*, particularly interesting. The texture of the lush green grass was created using a hog hair paintbrush—an unusual choice for watercolors given that the bristles of a hog hair brush are much firmer and flatter, and have straight, slanted, or rounded ends.

The paint used is a mixture of undiluted tube watercolor paint with slow-drying acrylic medium added to increase its flexibility and slow its drying time. The long vertical brushstrokes leave furrows and textured bristle marks in their wake, and the high horizon line maximizes the visual impact of the grassy area. As a point of contrast to this the sky is a sweeping sequence of softly blended wet-on-wet washes whose gray tones and hints of green link with the colors of the stone cottage and surrounding landscape. The cottage sits starkly against the skyline, its details picked out with much finer brushes and pens. Some of the stone shapes spilling out onto the grass were picked out using scratch-out effects.

Tip Gesso can be purchased premixed. It is used on paper here but can also be used to coat, or more accurately prime, other surfaces too, such as wood panels, canvas, and even 3D objects. To apply, pick a direction for the first light coat and let it dry, and add a second coat in a different direction. It can be sanded to achieve a very smooth surface.

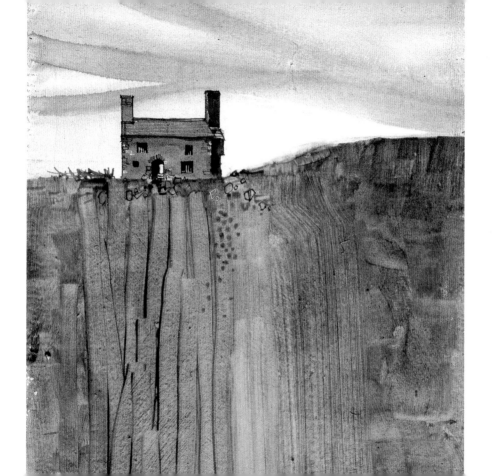

Creating the illusion of space Hatsuki Miyahara

In this acrylic painting, called *Cycling*, visual impact and the illusion of space are created by what appear to be colorful oval bushes that enter the frame from the left edge. A figure cycling around the central area moves in a direction away from the viewer. The space into which the figure cycles is given substance by the objects on the left. The diagonal side of the central reservation helps to "activate" the illusion of depth and create perspective.

Color is used cleverly. Its visual impact is obvious (this was used as a promotional piece for a Japanese magazine so it needed to be eye-catching). The colors of the foliage—red, green, turquoise, scarlet, orange, cerise—overlap to create new tones. Although this looks like an optical mix of wash layers, it isn't; a diluted acrylic mix was used.

A distinctive feature of this image is the tone of the paper on which it was painted. Most watercolors are painted on white paper to retain a crisp brightness of color, whereas this piece uses the cream tone of the paper to add warmth to the scene and to suggest that the cyclist's journey is a happy one.

Tip It is possible to purchase tinted watercolor paper in cream, oatmeal, eggshell, blue, and gray. These tinted papers are worth experimenting with.

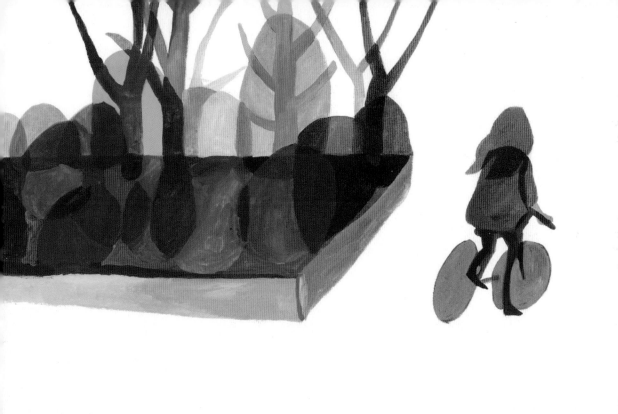

Varying opacity

Nikki Painter

This colorful and abstract work, called *10 (Verge)*, was painted and drawn onto a collage of layered paper. Geometric shapes and patterns vie with one another, leaning this way and that. The use of diagonals, which tends to suggest movement, adds energy to the composition as does the bold use of color. Watercolor pencils were used on the right to make diamond blocks of color over various black-lined papers. They provide a fluorescent zing of pinks, lime, and lemon and are echoed by a grayscale version at the bottom center. This muted area cleverly picks up on the blacks of the background papers. To the left of this, the area was completed using the same pencils but applied more opaquely (using a brush and a little water can increase their opacity further). The section to the left of that was painted with gouache paint. The colors used are tints of those used in the other areas.

I've described this image in terms of sections, but it's actually an image made of overlapping elements that read as one. It is useful to have another look at how those transparencies of color are mixed and layered—they're very subtly handled.

Tip Having a collection of subtly patterned papers is useful. The insides of envelopes printed with security designs are a good source.

167

Soluble and insoluble

Lieke van der Vorst

This sensitively handled image, *Winter Hug*, sits somewhere between drawing and painting and uses a range of materials, including watercolor pencils, ordinary colored pencils, and black pen. The pencils were used to emphasize the surface texture of the paper—their application really does suggest the wooly texture of those large winter coats. The ordinary pencils and black pen were used because they are permanent (rather than water-soluble), which will help the piece retain sharp definition.

Watercolor pencils are suitable for wet and dry paper and can be blended with a paintbrush. In this example, a small brush was used on dry paper to carefully blend the black areas on the mittens, pants, and shoes, with a light touch of yellow ocher and burnt sienna added too.

Tip When applying watercolor to a mixed-media image, use a smallish paintbrush so as to minimize bleed from details on the paper that have already been drawn.

Layering acrylic washes

Yoshinori Funayama

The elevated perspective offered by this painting, *Twins' Room*, gives us an interesting view onto the objects it contains. We find ourselves looking down on the twin girls, from where we can also see the tops of the table and piano. Interestingly, we're being watched by the cat, who is more or less level with us.

The painting has a grainy texture, produced by the wooden board and acrylic washes that form its base layers, that gives it a painterly feel. The green-brown area in particular is characteristic of acrylic paint built up in thin layers. These near-transparent layers of paint were brushed thinly across the surface, allowing underlying color and texture to show through. Importantly, acrylic wash such as this dries rapidly and is permanent, allowing it to be overpainted without any adverse effects. This also means it can't be lifted out with water, brush, or cloth, as watercolor can. Elements of the piece were developed digitally. The gray oval rug under the piano and the black dress of the girl on the right were produced in Photoshop—carefully enough that they blend seamlessly with the rest of the painting. After this, the surface scratches and ink and pencil details were added.

> **Tip** A distressed surface can be achieved by gently rubbing your finished painting with sand- or glasspaper. Gouache paint can be creased and cracked too by gently (or not so gently!) folding or similarly distressing the paper.

Experiment with mark-making

Jennifer Davis

In this piece, *Night Voyage*, the artist was commissioned to paint the client's favorite animals: a whale, a walrus, a rabbit, and a dodo. In addition, the artist decided to add her favorites too: a cat and a monkey. She used the night scene in a playful way. Gouache paint was used to achieve a thick matte look in the darker areas and to allow highlights to be applied over darker colors. A benefit of gouache is that it will cover up any initial line work laid down as a guide.

The artist added detail to the whale and water by applying scratch marks using the wrong end of a paintbrush. This is why she chose board as the medium; she knew it would be strong enough for these more forceful distressing techniques.

Tip It is possible to mix gouache with water, allowing you to achieve varying degrees of opacity. When thinned a lot, the appearance of gouache is almost indistinguishable from watercolor.

The rule of thirds

Elissa Nesheim

This miniature watercolor, *Colorful Abstracts*, was created according to a principle of composition known as the rule of thirds. To understand it, imagine your canvas is divided into nine parts by two evenly spaced horizontal lines and two evenly spaced vertical lines. The rule states that by placing the details of your painting at the intersections of these lines you will achieve a more balanced, unified, and interesting composition.

A broad wash of blue across the top two-thirds of the image represents the sky. Then across the lower third, a band of earth-toned paint represents the land. Notice how the color washes overlap each other and produce "new" colors, which become the hills. The clouds were formed by lifting up the blue wash with a paper towel and exposing the once-white paper. After letting the layers of paint dry, line details were then added. The surface looks heavily textured partly because canvas was used (see page 186 for information on painting a watercolor on canvas), and also because the piece's small size meant that the photograph was necessarily a close-up.

Tip Experiment by mixing varying amounts of ultramarine blue with burnt sienna; you will get some surprising results.

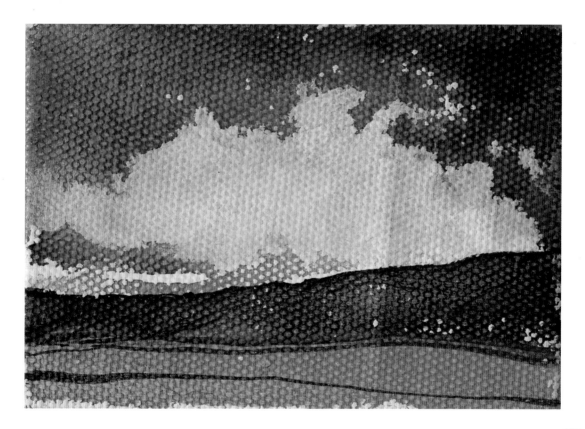

Representing animals

Kelly Puissegur

This artist considers herself a doodler of ideas, often inspired by oddities and funny, interesting, and strange things she encounters in movies, music, her neighborhood, animal behavior, and when with friends and family. Before beginning any painting, she spends time collecting ideas in her sketchbooks.

This selection of her work (clockwise from left, *Arm Wrestle, No Parking on the Dance Floor, Girl Fight*, and *Bonjour* [two pieces]) makes use of anthropomorphism, whereby animals are given human characteristics and qualities, in order to illustrate stories. Many cultures have traditional tales with anthropomorphized animal characters who can stand on hind legs or talk like humans. Here they're put into contemporary, multimedia settings where they dance, arm wrestle, and cycle too. They are rendered using water-based paint, pen, pencil, ink, wood, paper collage, and sometimes scans. Each piece is on a watercolor-washed fiber and tissue paper base that has been collage-pasted onto wood.

Tip Fiber paper, which can come from diverse sources, is not usually suitable for watercolor work. It tears easily when wet and paint will soak too readily into its surface. Try adding gel medium to it or using it as a pasted layer over a more suitable paper stock. Note, however, that some gels and pastes, when dry, will not absorb water-based paint, making them unsuitable for watercolor painting.

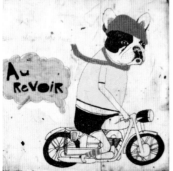

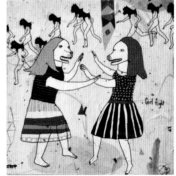

Painting on wood

Jennifer Davis

A girl sits on the floor, her skirt fabric settling in a circle around her. The circular form of her skirt is echoed by the gray oval behind her and the red flower in front. The patterning that the pleats of her skirt make is repeated elsewhere too—in the stripes of the wall and in the lines of the gray objects and the yellow petals.

Geometric forms dominate this painting, *Blooming*. They are used to structure it and to link the various elements. They overlap one another, and encourage our eyes to investigate the space between each of the elements. The image is painted on wood and employs various water-based media, which represents an unusual combination. The artist is interested in creating an opaque but distressed surface that is alternately built up and then taken away. To begin, she primed the wood with water-based white household emulsion, allowing it to dry, and then worked through a number of mixed-media techniques. These included applying multiple thin layers of wash, as well as laying down thick, dry layers of gouache and graphite. Once applied, she sanded and scraped these back, working and reworking the surface until she was satisfied with the result.

> **Tip** Mixed-media experimental works may need more attention paid to them if you intend to sell or exhibit them. Fixing, varnishing, and framing behind glass may all be necessary to preserve the work.

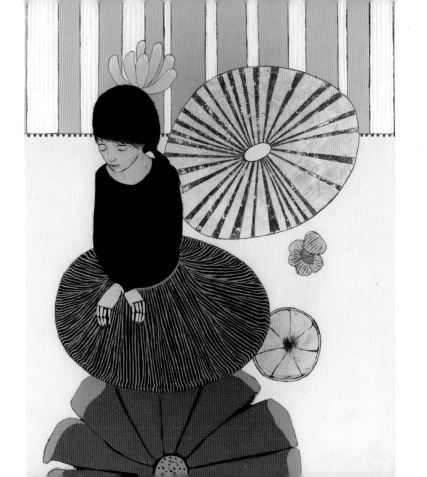

Aquabord™

Betsy Walton

The grayscale landscape of this painting, *Little Flame*, was created in a loose and experimental way with wet-on-wet drips, rivulets, blooms, and stains. Successive washes were layered on a subtle warm-colored surface, their tones ranging from the palest gray through to black, and then unusually to white. They provide the base for finer details that bring color to the scene at a later stage.

Interestingly, the surface chosen for this painting was not stretched paper (typical for this kind of work) but a hardboard called Aquabord™, which is clay-coated. It acts like a hot-pressed watercolor paper but with an important difference: color can be lifted off while the paint is wet or dry.

The finer details of this imagined landscape were applied when the wash sequences were completely dry. Lines, geometric forms, fronds, leaves, and saucer-like flowers are depicted in red, light blue, white, and pale yellow. They are very carefully painted, in contrast to those earlier experimental stages.

Tip If you wish to exhibit Aquabord™ works they don't need to be protected behind glass. Simply seal finished watercolors or gouache with several light coats of spray varnish (or fixative).

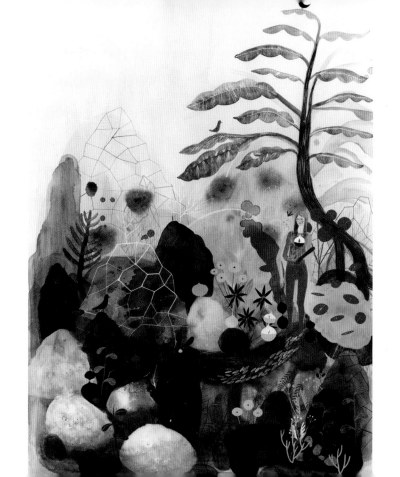

Flat color

Karen Barbour

This painting, *Two Figures Holding Hands,* was produced using gouache on wood. It has a distinctive feel that might be described as traditional or "folk." The two figures are apparently dressed in a national costume and are holding hands as though about to dance. The less-tutored style, characteristic of "folk art," looks flatter and slightly abstracted, as though part of a pattern, with interesting variations of proportion and perspective.

Despite the painting's apparent naivety, the techniques used are sophisticated. The wood was primed with layers of gesso to help inhibit absorption of the gouache paint and thereby maintain its brilliance. The palette, or color range, was limited to red, blue, mustard yellow, black, white, and brown, and tints of blue and black were used for the highlights (for example, the gray background, the pale blue floor). Rather than give form to the figures the paint is intended to achieve an appealing flatness.

Tip Traditional gesso, a mixture of glue binder with chalk and white pigment, is best used on rigid surfaces to reduce the risk of cracking. A modern version, "acrylic gesso," can be used on more flexible surfaces. Surfaces prepared with either are ideal to paint on, and not just with water-based media.

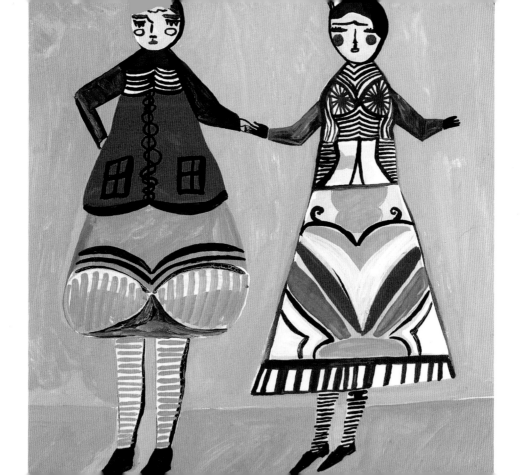

Painting on Claybord™

Betsy Walton

Broad color washes, wet-on-wet, determine the compositional foundations of this painting, *Three Houses in the Field*: a blue wave at the top for the clouds, and a concave dome at the bottom for the hill. The brushstrokes are broad, loose, and work to map out the space. A mop brush, decorators' brush, or sponge applicator would all be appropriate for this. The Claybord™ panel used for this painting was given a clean-water prewash to help ensure that subsequent color washes were more even.

The next stages of this painting were completed using smaller round brushes and a wet-on-dry technique. Gouache paint was added to give a solid color contrast to the base wash. The trees and shrubs—which are essentially leaf motifs—were color-blocked in at different sizes. Blue, otherworldly flowers (a signature motif of the artist) were painted in and linework details added. The tip of a round brush was used for the houses' outlines, walls, and patterned roofs, and a smaller brush for the leaf veins, pink trees, and roots. Pencil was used to render the paths, benches, and an almost hidden creature in front of the house.

Tip Claybord™ responds to paint differently than paper so it's important to consider adjusting your brush technique. Try varying the lightness of touch and the stiffness of your brushes prior to beginning your painting proper. No.9 and No.6 round brushes are good all-purpose brushes. A mop brush is good for broad washes and sweeping brushstrokes.

Priming a canvas

Elissa Nesheim

Canvas is the common choice of artists working with acrylic and oil paints. It is less commonly used with watercolors, thanks largely to the fact that its surface is nonabsorbent. Before watercolors and canvas can be combined, the canvas must be coated in gesso and watercolor ground to increase its absorbency—a process known as priming. The artist behind the two pieces (from left, *Stormy Mojave Colors* and *Up the Hill*) shown here specializes in painting miniatures. Working at such a small scale tends to mean a quicker turnaround of paintings; it's a good idea to prepare canvases in batches so that there are always spares nearby, ready to use whenever they are needed.

The two featured pieces were produced through a combination of washes, lifting, and the use of Sumi ink to define details. Several coats of a spray varnish were then applied to fix the paintings and protect them against damage.

Tip Ready-made gesso can be purchased from well-stocked art supply stores. It is usually white, but can also be bought as clear, colored, and black. Remember that only opaque color will work with the darker versions of gesso.

Digital collage

Kelly Puissegur

In addition to water-based paints, this mixed-media illustration, called *Pug Love*, also includes collage, scans, pen, ink, pencil, and digital drawing. It is a multilayered mixed-media piece that explores and balances the possibilities of a variety of approaches, while still maintaining the feel of watercolor and gouache paintings.

In this painting two dogs sit squarely before us dressed in costume, their owners partially cut out of the frame. The title, and the T-shirt worn by one of the owners, suggests that this piece depicts a pug fan club of sorts. The clothing shown in this illustration—the vest, shorts, skirt, jacket, and the dogs' onesies—are all digitally manipulated collages created from pre-prepared and scanned painted surfaces. Clever use is made of the contrasts between opaque and transparent paint and textured and smooth surfaces that are set against a similarly scanned wood veneer background. Look at the woman's black jacket; washy black brushstrokes suggest a velvet-like fabric, whereas the brushwork on the larger dog's costume suggests a more casual fabric.

Tip Consider painting over printouts of your photos. Remember that most home printers will contain water-soluble pigment ink—washy watercolor play is better for these. Gouache and acrylic will work well over laser prints too.

Watercolor fundamentals

Materials

Watercolor painting requires only a few materials—paints, paper, water, and brushes. Within these categories, however, the range of equipment available is so vast that it can be bewildering. This section provides you with concise information about the types of basic materials available to you and what to consider purchasing based upon how, what, and where you want to paint.

Paint
Acrylic paint
Acrylic paint can be used as an opaque medium or can be watered down and used like transparent watercolor. Once dry (it dries quickly) it can't be reconstituted or reactivated with water. It is good on canvas and paper surfaces, and for applying layers that won't be "disturbed" by the application of additional washes over it, and for creating texture.

Gouache
When used thickly, gouache is completely opaque. Unlike translucent watercolors, it can be used to paint light over dark and can also be diluted with water for semi-transparent washes. When purchasing your gouache color selection, remember to include black and white too.

Acrylic gouache is also available, which is similar to traditional gouache but is mixed with an acrylic binder, making it water-soluble when wet and water-resistant when dry. It can be used as a transparent or opaque color. Watercolor and gouache can be mixed with one another and can be "reactivated" with water even after drying. Experimentation with color is useful, provided you keep a record of the outcomes.

Watercolor paint
Transparent watercolor paint is available in two forms: as pans (solid cakes of pigment) or in tubes. Typically, they are used to layer translucent color washes on a white paper base, which combine with previous washes and with the paper beneath them, rather than fully concealing either.

Pans are available as whole- or half-cakes of paint. They are usually purchased in a box or tin but can be bought individually. Tubes contain soft color and are useful for mixing large quantities of paint.

Other water-soluble media
Permanent ink

Water-resistant and waterproof inks such as Indian ink and Sumi ink are invaluable for some approaches. Washes and fills can be laid down over them without disturbing the crispness of any pre-drawn dip pen or brush line work. (Don't use shellac-based ink in fountain pens as it will clog them up.) Washes over ballpoint pen work too.

Pigment or dye ink

Pigment inks are lightfast so are better for works produced for exhibition. Dye-based inks are brighter and more suitable for work you intend to reproduce by copying, scanning, and editing digitally. Most inkjet printers have dye-based ink in them—try adding water to a printout on heavier paper. Alternatively, print with it by pressing it against a dampened surface so the ink is reactivated and leaves a reversed copy of itself.

Watercolor pencils

Watercolor pencils look just like standard pencils but have water-soluble leads. They are not graded so make sure you test their solubility before you buy them. They come in a wide range of colors and can be used wet or dry, and on wet or dry paper. Because they're soluble you can blend and mix new colors easily, so start out with a basic range of colors. The marks of soft leads can be removed easily with water on a brush or finger, leaving a color wash behind. Harder leads provide a weaker wash and will leave an impression of the mark. Choose the right watercolor pencil for the effect you are after. Some watercolor pencils are available as "woodless" sticks or blocks. Using a block on its side is good for laying down large areas of color, plus it doesn't need sharpening.

Water-soluble crayons

These are similar to watercolor pencils, although they are encased in a paper wrapper rather than wood. They're softer and broader and enable pigment to be laid down faster than with a pencil.

Water-soluble ink

You can apply water-soluble ink with a brush, fountain pen, and dip pen. A dip pen can be fitted with a variety of different nibs to produce different marks. A fountain pen is good for working outdoors—the ink won't spill and is on tap. Adding clean water or color washes to either will make lines soften and merge. Note: many fine-liner pens contain non-waterproof ink. You can dilute both types of ink with water to change their tone. Some brands recommend that you don't use water from the faucet because it may cause the ink to "split." Use distilled water instead, unless of course you want the graininess of separation in your work. It is important to note that the colors of dye-based watercolor and drawing inks are beautifully luminous and bright but they are not lightfast. Only use them for work you intend to copy, scan, print, or store away from sunlight. Pigment-based inks tend to be lightfast and are good for work you intend to exhibit. Read the labels of anything you buy. If you purchase them from a good art supplies store, the specialist staff should be able to answer any questions you might have.

Cup #16
by Anne Smith

Paint additives

If you are new to watercolors, it is best to get the basics right before experimenting with additives. Watercolor itself is a versatile medium and may not require much in the way of additives. Using additives where they aren't needed can ruin a painting!

Aquapasto/impasto gel

This thickens watercolor paint to reduce bleeding and flaring. It is good for multicolored brushstrokes, although it is hard to remove once dry—be sure to wash your brushes immediately after use.

Granulation medium

This medium creates grainy and speckled effect that can be used to add interest to flat areas. Some colors, such as ultramarine and cerulean blue, raw sienna, burnt sienna, and burnt umber, separate naturally. Others will separate when mixed with water from the faucet rather than distilled water.

Gum arabic

This adds body to paint, making it thicker and glossier. It slows drying time, makes colors more luminous, and adds definition to brushstrokes. Gum arabic enables paint to be scratched back to the white paper, although overuse can make the surface brittle.

Salt

A range of textures and effects can be achieved by sprinkling salt onto a still-wet painted surface. The results will depend on the size of the salt crystals, the type of paper, the wetness of the surface, and the paint used.

Texture gel

This gel contains particles that create a 3D or impasto surface not usually associated with watercolor work.

Watercolor medium/ox gall

This is used in wet washes or straight from the bottle. It enhances flow and can create many surprising effects, although these vary from color to color.

Paper

Watercolor paper is generally white ("bright" or "natural") so as to reflect light back through the thin layers of paint. It needs to be suitable for water-based media, including the wettest wash, but also for more delicate dry brushwork or perhaps ink or pencil detail. There is a large range of watercolor paper available, which varies in thickness, weight, texture, and tone, available as single sheets, drawing blocks, pads, and sketchbooks. You can purchase these from your local art supply store or order them online. Going to a store will allow you to examine the paper and therefore make a more informed choice. Plus, specialist art store staff will be at hand to answer your questions. Online purchases are convenient for those who know in advance which paper they want. Note that a greater variety of surfaces can be used when working with gouache. As mentioned previously, its opacity makes it suitable for use with colored paper as well as white. It also works well on lighter handmade papers from India, Japan, and China.

Cold-pressed or "NOT" paper

The latter of these names derives from the fact that the paper is not hot-pressed. NOT papers are the most commonly used paper among watercolor artists. They are generally considered the easiest to use because they allow traditional watercolor effects such as granulation to settle into lower parts of the tooth, with dry brushing applied over the high points of the paper's surface.

Hot-pressed paper

This smooth paper is created by passing paper between heated rollers. It has almost no tooth, meaning that less paint is absorbed and the paint dries faster. It's good for large, flat washes, illustrations, fast paintings, and also for detail such as fine pencil or pen and ink work. It's excellent for flatwork intended for reproduction.

Rough papers

These have a rough surface because they are pulled directly from the mold and are not flattened or ironed between cylinders. They have the highest tooth of any watercolor paper, with a coarse and bumpy surface that draws paint deep into it. Rough papers are good for creating textures.

Stretching paper

The thickness or weight of paper helps determine whether or not it should be stretched before it is used for watercolor painting. The weight of paper is expressed in pounds (lb.) or grams per square meter (gsm) and refers to the weight of a ream of 500 sheets rather to a single sheet of paper. A good rule is that any paper heavier than 200 pounds (300 gsm) can be used without stretching. Most watercolor pads contain paper of 140 pounds (210 gsm). As the sheet size is generally smaller in these and a closed book will help flatten work (after it has been allowed to dry) the page shouldn't need stretching. The bigger the piece of paper the more important it is to stretch it. If it wrinkles and distorts, which is more likely the more water you apply to it, certain techniques just won't work.

Although stretching paper may seem like a chore, it is worth it. For a start, you will save money because lighter papers are cheaper than heavier ones. Additionally, stretched paper is more pleasant to work on as it will have no ridges and won't buckle.

Although you won't want to skimp on your paper, it isn't necessary to buy the best handmade papers when starting out. The finest-quality watercolor paper is handmade using cotton or linen rag (they often have deckled, or feathered, edges and a watermark). If you're a beginner, or depending on the kind of work you're doing as a more advanced painter, machine-made papers are good too. Just note the weight and surface quality.

Other varieties of paper include: tinted watercolor paper (Bockingford), which is available in cream, oatmeal, eggshell, blue, and gray; Asian papers, which vary greatly in thickness and absorbency but are definitely worth experimenting with; and "found" and vintage papers, which require a good deal of experimentation in order to establish their suitability for watercolor and gouache painting.

Other surfaces

Claybord™

This is an ultra-smooth, absorbent, kaolin clay-coated hardboard panel that works superbly well with watercolor, gouache, ink, and acrylics. Thin coats can very easily be lifted and reworked. It can be scratched to add contrast, texture, and fine details, and colors stay true on it. After sealing and varnishing, work can be framed without glass and it is archival and acid-free.

Aquabord™

This is similar to Claybord™ but is specifically designed for watercolor. Washes, layers, and glazes can be repeatedly lifted back to white without damaging the surface. No stretching is needed and it won't buckle under heavy water applications. Its smooth surface is similar to hot press paper. Watercolor gesso is available from a number of different manufacturers in variously sized containers. Use a flat brush to apply it to hardboard or perhaps a wood panel. It dries to a chalky, plasterlike finish and can be applied roughly to leave a surface texture or sanded to make a smooth, flat surface.

Cup #86 by Anne Smith

Equipment

Brushes

The hairs on a brush can be natural, synthetic, or a mixture of the two. Brushes made from natural materials are more expensive, especially sable ones, but they hold more water and retain their shape better. Many synthetic brushes get close to the quality of brushes made from natural hair, but they tend to wear a little faster. A mixed natural and synthetic brush can be a good compromise. Never leave brushes standing in water. Rinse them under running water after each painting session and then reshape them gently with your fingers or lips. Leave them to dry flat before storing.

Begin with just a few brushes; you'll be able to achieve a lot of different marks and effects with them. The three main shapes are rounds, flats, and mops. Brushes are sized using a number system—the bigger the number the bigger the brush. Flat brushes are sometimes measured in inches or centimeters rather than numbers.

Easels

Although not essential, they are useful for holding your board and paper at the right height and in the correct position rather than awkwardly positioned on your knees. Wooden and metal easels are both good. If you decide to buy one, make sure it is lightweight, easy to carry and assemble, and, crucially, allows you to use it in a horizontal position for when you want to do washes.

Palettes

For large washes you'll need a palette with deep recesses. When doing smaller, detailed work you'll need smaller recesses, but perhaps a greater number of them to cope with all of the different colors. They are usually plastic, ceramic (an old plate will do), or enameled metal, such as the kind found in the lid of a pan or tube watercolor set. Always use a white palette in order to allow yourself to gauge the color of the paint accurately. In addition to the palette, a water pot (or two) is needed.

Sketchbooks, pads, and blocks

These are either glued along the edge or spiral-bound. The spiral version is best for keeping work together,

whereas glued pages are best for easy page removal. Watercolor paper blocks are glued on all four sides so there is no need to stretch the paper prior to painting. Remove work by inserting an X-Acto knife between the sheets, splitting the glue until the sheet breaks away. All come in a range of sizes, from postcard size upward.

Other paint tools and mark-makers

As you develop your skills you will find that there are plenty of tools and mark-makers to choose from, each with unique properties.

Diffusers and sprayers

Filled with clean water, these can be used to dampen paper in order to keep the surface active. Filled with paint or ink, they can also be used to create splatter effects. A toothbrush is good for splatter work too.

Everyday materials

These can include bubble wrap, plastic wrap, aluminum foil, baking parchment—all of which can be pressed into wet washes to create texture.

Natural and synthetic sponges and applicators

These are used for dampening large areas, applying washes over large areas, creating textures, and lifting color. Cut to shape, sponges can be used to print blocks of color. A sponge with a plastic handle is good for broad, wet work.

Japanese brushes

They have a conical shape and a long thin point, which makes them good for calligraphic flowing lines, textures, and more. An entire painting can be completed with one of these.

Paint shapers

This is a silicone-tipped tool available in a variety of shapes and sizes, that is used for applying and removing color. It is excellent for applying masking fluid as they're much easier to clean than brushes.

Drinking straw/hairdryer

Useful for moving paint or ink around, and for drying work more speedily.

Masks and stencils
Masking fluid
This is good for creating defined edges and textures. It protects areas of your work (most often white areas) when color washes are applied. Do not use it on delicate or wet paper as it will be very difficult to remove. Although it can be applied with a brush, it is better to use a silicone-tipped applicator, which is much easier to clean after use.

Sandpaper and bleach
Sometimes it's useful to remove colour e.g. for highlights. A gentle rubbing with sandpaper can remove (dry) paint back down to the paper surface. Bleach is more dramatic. It has an instant effect on liquid watercolor and water-soluble inks, bringing whites back by revealing the paper surface again. Be careful with it. Wash brushes immediately after experimenting and always use synthetic rather than natural-hair brushes.

Torn or cut paper
Using paper to mask areas of white or previously laid washes is an easy and effective option. Cut paper will give a crisp, straight edge and an X-Acto knife can be used to produce specific patterning, decoration, and design motifs. Using a spray diffuser can make them appear almost screenprinted. Torn paper will give a softer, uneven edge. Masking tape—usually for securing paper, is also useful as a mask too—cut or torn.

Wax
Wax repels water, meaning that marks made with wax crayon will resist watercolor washes. Different effects can be achieved depending on the tooth of the paper.

Central Park by Arthur Kvarnstrom

What next?

Consider what to do with the paintings and illustrations you've made. Depending on the media you've used to make them, there are a variety of choices open to you. Perhaps you've experimented with a range of water-based media in a sketchbook or you have a sequence of single-sheet paintings. You might want to store them safely as private experiments or as artistic research for later reference. Or you may wish to share them with others. Don't make any snap decisions—whether you're simply playing with media or have ambitiously made a painted picture, everything has value. Don't throw anything away. Once dry, store your images for a while and try some of the following tips.

Research other artists' work

Never underestimate how important it is to look at the work of other artists. Visiting nationally acclaimed art museums or visiting local galleries is going to allow you to see work as it really is—for instance, its scale, the vibrancy of colors, surface qualities, brushwork,

advantageous lighting and positioning, how it is framed, and so on. You'll be able to pick up ideas and perhaps more importantly create a dialog with others. All good museums have their own websites, many of them with sections devoted to watercolor.

Watercolor exhibitions

Museum of Modern Art (MoMA)
moma.org/search/collection?query=watercolor

National Gallery of Australia
nga.gov.au/Google/SiteSearch.cfm?q=watercolours

Tate Britain
tate.org.uk/whats-on/tate-britain/exhibition/watercolor

Victoria and Albert Museum
vam.ac.uk/page/w/watercolors

You can also gather and curate your own online collection. Here's mine:
pinterest.com/drawdrawdraw/watercolour-water-based-media/

Artist groups

Consider joining groups to show, share, and discuss your work. This may involve going out on group painting and drawing field trips or it might be an online society. Don't settle for the first you find; each online community has its own particular kind of visual and verbal "flavor." Choose the one that you feel works best for you.

Flickr
flickr.com/groups/urbansketches/pool/tags/watercolor

The Sketchbook Project
instagram.com/thesketchbookproject

Urban Sketchers
urbansketchers.org

Watercolor societies

Always try to seek out good-quality watercolor work. Known societies are often a good place to start.

American Watercolor Society
facebook.com/AmericanWatercolor

Royal Watercolor Society
royalwatercolorsociety.co.uk/members.aspx

Exhibiting and selling

You may be confident enough to start showing and selling your work, in which case, the Internet is a good place to start. You should also consider entering your work into competitions.

Behance
behance.net/search?field=48&tools=8917

Etsy
etsy.com/market/watercolor

Saatchi Online
saatchiart.com/buy-art/for-sale?query=watercolor

Contributors

Ana Montiel: 70
anamontiel.com

Anne Smith: 193, 197
annesmith.net

Arthur Kvarnstrom: 72, 201
arthurkvarnstrom.com

Becca Stadtlander: 92, 104, 108, 114
beccastadtlander.com

Betsy Walton: 180, 184
morningcraft.com

Blanca Gómez: 124
cosasminimas.com

Cate Edwards: 44
flickr.com/cate_edwards

Cathy McMurray: 110
cathymcmurray.com

Charlene Liu: 50
charlene-liu.com

Dadu Shin: 134
dadushin.com

Daniela Henríquez Fernández: 52
flickr.com/danielahenriquez

David Hornung: 88, 122
davidhornung.com

Ekaterina Koroleva: 130
ekaterina-koroleva.de

Eleni Kalorkoti: 54, 98
elenikalorkoti.com

Eleonora Marton: 14
eleonoramarton.com

Elissa Nesheim: 174, 186
elissasue.com

Elizabeth Baddeley: 48
ebaddeley.com

Elizabeth O'Reilly: 34
elizabethoreilly.com

Emily Watkins: 66
emily-watkins.co.uk

Functional Fox (Matt La'Mont): 132
thefunctionalfox.com

Gabby Malpas: 74
gabbymalpas.com

Georgiana Paraschiv: 136
gpdsn.com

Hatsuki Miyahara: 164
hacco.hacca.jp

Helen Dealtry: 128
wokinggirldesigns.com

Helen Hallows: 140
helenhallows.com

Holly Exley: 26, 46
hollyexley.com

Itsuko Suzuki: 5, 156
itsukosuzuki.com

Jeannie Phan: 120
jeanniephan.com

Jennifer Davis: 172, 178
jenniferdavisart.com

Joanna Goss: 60
joannagoss.com

Julie Van Wezemael: 152
julievanwezemael.blogspot.co.uk

Junyi Wu: 12, 160
junyiwu.com

Kamilla Talbot: 68
kamillatalbot.com

Karen Barbour: 182
karnbarbour.com

Kasia Breska: 154
pencilboxgirl.blogspot.com

Kate Pugsley: 94
katepugsley.com

Kaye Blegvad: 16
kayeblegvad.com

Index

Acknowledgments

I'd like to say a massive thank you to everyone who has allowed me to use their work in this book.

—To the many anonymous online artists and curators for sharing their art blogs so full of visual delight and invaluable information.

—To all of the publishing folk for helping turn virtual into actual.

—To my mother Joyce (Cooper) Birch, who drew and painted so beautifully; thank you for everything, including my first watercolor paints.

This book is dedicated to my father (Philip) John Birch—because he painted a lime green house, and liked his mustard yellow tie.

Published in the United States by Watson-Guptill Publications, an imprint of the Crown Publishing Group, a division of Random House LLC, a Penguin Random House Company, New York.
www.crownpublishing.com
www.watsonguptill.com

WATSON-GUPTILL and the WG and Horse designs are registered trademarks of Random House LLC

Library of Congress Cataloging-in-Publication Data is on file with the publisher.

Hardcover ISBN: 978-1-6077-4757-4
eBook ISBN: 978-1-6077-4758-1

Printed in China
Cover design by Michelle Rowlandson
Interior layout by Michelle Rowlandson and Richard Peters
Design concept by Lucy Smith

10 9 8 7 6 5 4 3 2 1

First Edition

Front cover images (clockwise from top left): Luka Va, David Hornung, Peggy Wolf, Becca Stadtlander, Kotryna Zukauskaite, Vikki Chu, Simona Dimitri, Natasha Newton
Back cover images (from left to right): Joanna Goss, Elissa Nesheim, Ana Montiel, Ekaterina Koroleva